Our Fellow Kentuckians

Our Fellow Kentuckians

Rascals, Heroes and Just Plain Uncommon Folk

JAMES C. CLAYPOOL

THE
History
PRESS

Published by The History Press
Charleston, SC 29403
www.historypress.net

Copyright © 2009 by James C. Claypool
All rights reserved

First published 2009
Second printing 2011
Third printing 2012

Manufactured in the United States

ISBN 978.1.59629.648.0

Library of Congress Cataloging-in-Publication Data

Claypool, James C.
Our fellow Kentuckians : rascals, heroes and just plain uncommon folk / James C.
Claypool.
p. cm.
ISBN 978-1-59629-648-0
1. Kentucky--Biography. 2. Kentucky--History. I. Title.
F450.C536 2009
920.0769--dc22
[B]
2009013929

To Sharon

Contents

CONTENTS

Acknowledgements

One of the distinct pleasures of writing a book involves the opportunity to thank those who have helped in its birth. Foremost, thanks should be given to my wife, Sharon Hayes Claypool, who proofed the manuscript and to whom this book is dedicated. Another proofreader, my talented granddaughter Allsun Kettles, is also to be thanked. Several individuals helped gather images. Dr. Paul Tenkotte, a historian and coeditor with me of the *Encyclopedia of Northern Kentucky* (2009), helped transfer most of this book's images to disc. Bill Marshall and Jason Flahardy, at the University of Kentucky Archives, graciously aided in obtaining several key images. George Clooney's publicist, Stan Rosenfield, provided that actor's picture. Tony Tackett of the Country Music Highway Museum in Paintsville, Kentucky, provided the picture of Loretta Lynn. Lastly, I wish to thank John Wilkinson of The History Press for providing editorial support and Kathy Ferguson at the Kentucky Humanities Council in Lexington, Kentucky, for her support.

Introduction

This book features brief sketches covering thirty-nine fascinating men and women, all of whom have ties to the Commonwealth of Kentucky either by birth, through family heritage or by having lived in Kentucky. It is an expansion of a talk that I deliver each year under the auspices of the Kentucky Humanities Council. Thirty-nine short vignettes are but a select sampling from the long list of names that could be considered to fall within the categories established by the title of this talk and now by the title of this book.

The individuals included were chosen to represent the widest set of demographics, and like a wine tasting, the sketches offered are meant to give readers a taste for more. Chronologically, the book begins with Christopher Gist, one of the early white explorers of the northernmost regions of Kentucky. Next there is Daniel Boone and Simon Kenton, ranking first and second, respectively, among the famous frontier scouts and early settlers of Kentucky. Marine legend Captain Presley O'Bannon, the fearless pioneer woman Jane Crawford and statesman Henry Clay follow. Then there are Kit Carson and Jim Bowie, who affected the history of America's West, and Presidents Jefferson Davis and Abraham Lincoln, both of whom were born in Kentucky.

Cassius Marcellus Clay ("The Lion of White Hall"); Henry Stanberry, the architect of President Andrew Johnson's impeachment acquittal; and two of America's colorful Wild West figures, Judge Roy Bean and Jack McCall, come next. Nancy Green, the first Aunt Jemima; Ralph Rose of Olympic fame; Boy Scouts founder Daniel Carter Beard; African American inventors Elijah McCoy and Garrett Morgan; and John T. "Machine Gun" Thompson add variety. Spelunker Floyd Collins and controversial creationist figure John Scopes shift the focus to well-publicized public dramas.

Alben Barkley and A.B. "Happy" Chandler provide political components, while jockey "Eddie" Arcaro brings the sport of thoroughbred horse racing

to the mix. Prominence in the musical field is demonstrated by the life of Bill Monroe, "the Father of Bluegrass Music." The significant roles played by Kentuckians during World War II is represented by the lives of Admiral Husband Kimmel in command of U.S. Naval Forces during the bombing of Pearl Harbor, Rose Will Monroe ("Rosie the Riveter") and Franklin Sousley, a marine who helped raise the flag atop Mount Suribachi in 1945. The acting career of Victor Mature takes the reader to Hollywood and the fantasy land of "the silver screen," and Loretta Lynn's life story illustrates the determination it took for her to become the reigning "queen of country music."

The final eight entries expand the reader's horizons even further. Duncan Hines and Harland Sanders illustrate how two men based in Kentucky used their talents to spread the Commonwealth of Kentucky's name and image for hospitality, good food and good cooking worldwide. The life of Colonel Lelia Busler and her connection to the famous MASH unit that served in Korea offers several unique insights, as does the story of one of Kentucky's all-time high school basketball greats, "King" Kelly Coleman. Muhammad Ali stands alone, a seemingly simple man yet so complex. Helen Thomas, from Winchester, and Diane Sawyer, from Glasgow, shine brightly as highly acclaimed professional journalists. And last, but not least, there is George Clooney, in his own life or in the movies, the embodiment of all three categories included in the title of this book—sometimes playing the part of a rascal, at times a hero, but, more often by his own choice, just a plain uncommon folk from Kentucky!

Christopher Gist

1706–1759

"Thanks Mr. Gist, I could have drowned."
Christopher Gist—frontier scout of Kentucky

Christopher Gist, a North Carolinian, is most commonly remembered for his groundbreaking explorations of the Kentucky and Ohio territorial frontiers during the early 1750s, but for Gist it was an act of heroism in rescuing a drowning twenty-one-year-old colonial officer from icy river waters that would have the most lasting historical impact. In 1750, Gist, a trained surveyor, was hired by the Ohio Land Company, which had acquired a grant for lands west of the Allegheny Mountains from the English king George II, to survey the company's vast new land tracts. Gist and a companion left Maryland in October 1750 and traveled down the Ohio River to near the mouth of the falls of the Ohio at present-day Louisville, Kentucky. They were turned back by a party of friendly Indians who warned them that there were hostile Indians in the area. A year later, Gist moved to Pennsylvania and, in 1753, because of his knowledge of the lands west of the Alleghenies, was hired to lead a mission ordering French troops to leave the disputed Ohio Territory that was initiated by Robert Dinwiddie, the lieutenant governor of the Virginia Colony. Dinwiddie chose Virginia colonial Major George Washington to deliver this ultimatum.

The expedition was undertaken in the dead of winter under miserable weather conditions. On the return, after Washington had completed his mission, an event took place that would affect significantly the course of American history. In a journal he was keeping, Washington recounts that upon coming to a frozen river there was no way to cross but by raft. He continues, "The Rapidity of the Stream threw it [the raft] with so much violence against the Pole, that it jerked me out into ten Feet of Water." Gist, thrown into freezing waters beside Washington, dragged Washington to shore, thereby saving the life of the man destined to become the father of the future American nation.

by
Allan Powell

Christopher Gist and George Washington in 1754 outside a French fort in the Ohio Territory. Lithograph by Sears Gallagher, 1932. *Courtesy of William Gist.*

On his return to Williamsburg, Virginia, Washington immediately published an account of the expedition, a bestselling book that was said to have placed his name in the forefront of colonial military officers throughout the breadth of colonial America. Gist, who later was made an officer and scout in the Virginia militia, died in 1759 of smallpox at Winchester, Virginia, while leading an expedition en route to the Virginia border. The most noteworthy tribute to Gist in Kentucky is a historical society in northern Kentucky, the Christopher Gist Historical Society.

Daniel Boone

1734–1820

"I can't say I was ever lost, but I was confused once for three days."
Daniel Boone—frontier explorer, scout and settler, one of the first white men to explore Kentucky

Daniel Boone, the most heralded early explorer and settler of Kentucky, was born in 1734 in a log cabin in Berks County, Pennsylvania, the son of Quaker pioneers Squire and Sarah Morgan Boone. Boone had little formal education. He spent his early years working on the family farm and hunting. When he was twelve or thirteen his father gave him a gun, which Boone used to hunt game to provide food for the family's dinner table. Daniel's father was expelled from the Society of Friends (Quakers) because his eldest unmarried daughter got pregnant and one of his sons married a non-Quaker. In 1752 or 1753, Squire Boone moved his family to the Yadkin Valley of North Carolina.

In 1756, Daniel Boone married Rebecca Bryan, a woman who showed great patience, given her husband's habit of disappearing into the wilderness, his fate unknown to her for months at a time. In 1769, John Finley, a comrade of Boone's during the French and Indian War (1754–63), visited Boone at his cabin in North Carolina. Finley was looking for a way to enter Kentucky by an overland route and needed a skilled guide to lead him. Boone had already visited Kentucky with his brother in 1767 on a hunting foray and agreed to help Finley in his quest. Finley's goal was to locate the "Warriors' Path," the route the Shawnee and other Indian tribes used to enter and leave the Carolinas from Kentucky. It was said that Kentucky was teeming with game and Finley hoped to make his fortune trading furs.

Boone, always up for adventure and wanting to see more of Kentucky, departed the Yadkin Valley on May 1, 1769, at the head of a party of six men, including his brother-in-law, John Stuart. It was the start of many ventures deep into Kentucky by Boone, as well as the foundation of his legendary

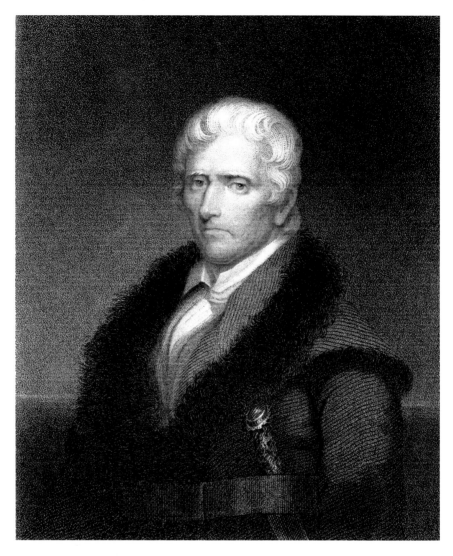

Daniel Boone. *Courtesy of Special Collections & Archives, University of Kentucky.*

work as a wilderness explorer. Passing through the Cumberland Gap into Kentucky and setting up camp on the banks of the Rockcastle River in south central Kentucky, Boone ascended a knob and got his first view of the fertile meadowlands that lay ahead. His love affair with Kentucky had taken root.

Boone's venture into Kentucky in 1769 could hardly be termed a success. He and his companions lost the furs they had gathered to a party of Shawnee Indians who confiscated them and warned Boone and his companions to get out of Kentucky. Boone and his party took this warning seriously and

headed home. On the way back, Boone met his brother, Squire, and another man entering Kentucky to trap, and Boone and Stuart joined up with them while the remainder of Boone's original party returned home. This time the Boone brothers and their companions camped well away from the Warriors' Path and Squire Boone was twice able to take furs back to sell in North Carolina. Stuart, however, was killed by Indians and the fourth man, Alexander Neely, decided to return home. While his brother traveled back to North Carolina, Daniel Boone made good use of his time alone by exploring along the Dix, Kentucky and Ohio Rivers. These wanderings made Boone the most knowledgeable white explorer of Kentucky then living.

Boone returned to Kentucky for a third time early in 1773 with a small group of men; at that time, he resolved to come back as soon as possible to attempt to build a settlement. However, this was to be a venture that would end in disaster. Boone, his oldest son James and five neighboring families from North Carolina came back to Kentucky later in 1773 to settle, but some of their party, including Boone's son, were attacked by hostile Indians. In the fighting that followed, all of these settlers were either killed or captured, and those who survived the fight, including Boone's son, were tortured to death. After discovering this, Boone and the others decided to return home.

Though a simple man, Boone was about to get caught up in a complicated swirl of frontier rivalries and land speculation. Over the next three years, 1774–76, the fate of Kentucky would be played out by contending settlers or by land claimants from three states—Pennsylvania, North Carolina and Virginia. In June 1774, a party of thirty settlers from Pennsylvania, led by James Harrod, established a settlement in central Kentucky at modern-day Harrodsburg. However, Harrod and the other Pennsylvanians were forced to withdraw in July 1774 because of Indian attacks. They returned in March 1775 and began to erect a stockade. Meanwhile, Judge Richard Henderson, a North Carolina land speculator, had signed a treaty with the Cherokee in March 1775 purchasing their land rights in Kentucky and Tennessee, after which he hired Daniel Boone to cut a road into Kentucky ("Boone's Trace") and to build a fort south of modern-day Lexington that became Fort Boonesborough.

However, Virginia, which considered its claims to Kentucky as being preeminent, moved quickly to counteract both of these developments. First, Virginia's governor, Lord Dunmore, declared that Henderson's purchase violated Virginia's territorial boundaries. Then a Virginia militia officer, George Rogers Clark, was sent to Kentucky to give Virginia a military presence there and to see to it that Virginia's land claims prevailed. Moreover, when Henderson convened the settlers from Harrodsburg and the other

settlement stations that had sprung up in Kentucky and told those assembled that he was their landlord, he was rebuked and told to get himself back to North Carolina. Finally, in December 1776, at the onset of the American Revolution, Virginia created Kentucky County out of Virginia's Fincastle County. Clark was given five hundred pounds of gunpowder by the Virginia legislature for the defense of Kentucky County. By these actions, Virginia assumed both political and military control of Kentucky.

The Revolutionary War era, 1776–83, was marked by many adventures for Daniel Boone and his family. He had moved his wife and children with him to Fort Boonesborough in 1775, and the next year Shawnee warriors kidnapped Boone's daughter and two other girls. Two days later, Boone caught up with the Indians, launched a surprise attack and rescued the kidnapped girls. Later, in 1778, Boone was captured by a band of Shawnee and taken to their village in Ohio. The Shawnee admired Boone for his bravery and wilderness skills and adopted him as a member of the tribe. After learning that the Shawnee were planning an attack on Fort Boonesborough, Boone made a daring escape back to the fort in time to warn its defenders of the attack, covering 160 miles in four days, first on a pony and then by foot. Boone, who had been held captive by the Shawnee for five months, was accused of treason by a jealous rival, tried, found not guilty and promoted to major for his dedicated service.

Things did not get much better for Boone and his family during the final years of the American Revolution. Boone had great difficulty establishing his land claims in Kentucky, especially since the execution of these claims ultimately had to be ratified by land courts in Virginia. Adding to his problems was the fact that Boone was robbed in 1780 at a tavern in Virginia of money entrusted to him by friends and, honor bound, Boone spent the next few years repaying this debt. Boone and his family were dealt another severe blow at Blue Licks in Kentucky in 1782 when a division that Boone was commanding was attacked by Indians and Boone's son Israel was killed.

From 1783 until 1790, Boone and his family lived first at Maysville, Kentucky, and after that at Point Pleasant in Kanawha County in what is modern-day West Virginia. While living in Maysville, Boone operated a trading post; after moving to Point Pleasant, he served as a county representative from Kanawha County to the Virginia assembly. In September 1799, Boone, who was nearing age sixty-five, moved to Spanish-controlled Missouri. When the Missouri Territory became part of the United States because of the Louisiana Purchase in 1803, Boone once again lost most of the land that he had claimed. Rebecca Boone died in 1813, and Daniel died seven years later on September 26, 1820. Boone was buried in Missouri, but

twenty-five years later both he and his wife were reburied in a cemetery in Frankfort, Kentucky.

Stories about Daniel Boone and his wilderness adventures abound. For instance, he reputedly told his son Nathan that he could not say for certain that he had ever killed an Indian despite his reputation for being one of the greatest Indian fighters ever. John Filson, who published the first history of Kentucky in 1784, devoted half of his book to Boone and his exploits. Whatever part of the Boone story is legend, and some of it is, the indisputable fact is that Daniel Boone remains one of America's most famous early frontiersmen, a man whose life personified the restless spirit of adventure that propelled Americans as they expanded their new nation from coast to coast.

Simon Kenton

1755–1836

"Glad to make your acquaintance Mr. Boone, I go by the name of Simon Butler."
Simon Kenton—noted Kentucky frontiersman

Simon Kenton, son of Mark and Mary Miller Kenton, was born in 1755 on a farm located in the Bull Run Mountains of Virginia. Even as a young man, Kenton was intrigued by stories of the Kentucky frontier, an area that was still part of Virginia when he was growing up. Kenton spent much of his childhood helping his father on the farm and therefore had little time for schooling; he remained illiterate his entire life and was only able to sign his name.

At age sixteen, Kenton got into a fight over a girl with a boy named William Leachman, whom Kenton knocked unconscious. Thinking he had killed his adversary, Kenton assumed the name of Simon Butler and fled Virginia, eventually ending up in Pittsburgh, Pennsylvania. There he met some frontiersmen whose stories of their adventures in Ohio and Kentucky caused Kenton to decide to travel down the Ohio River in search of the "cane lands" of Kentucky.

After several setbacks, Kenton and a companion, Thomas Williams, entered Kentucky in the spring of 1777 at Limestone Creek (the present site of Maysville, Kentucky). They made a camp, cleared the cane and planted a crop of corn, thought to be the first corn crop cultivated by white men north of the Kentucky River. Hostile Indians, however, remained a real threat, and it seemed just a matter of time until they would attack Kenton and his companion. When Williams departed in the fall, Kenton fled to safety at Fort Boonesborough in central Kentucky, where he first met Daniel Boone.

Kenton traveled through Kentucky with Boone and General George Rogers Clark meeting other pioneers over the ensuing years. In 1777, Clark appointed Kenton a spy for the defense of the frontier, and later Kenton saved Boone's life during an Indian attack at Fort Boonesborough. Kenton

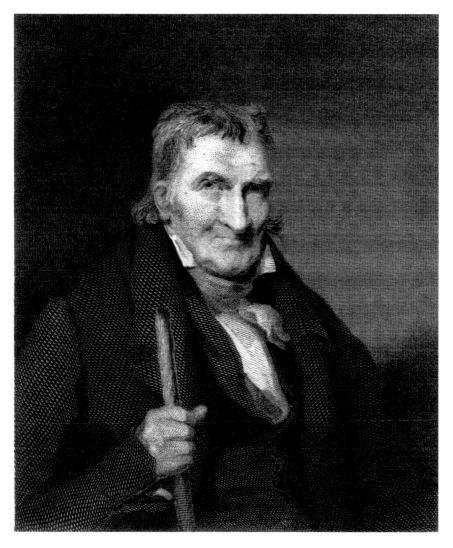

Simon Kenton. *Courtesy of Special Collections & Archives, University of Kentucky.*

also accompanied Clark into the Illinois Territory, where Clark would campaign and secure the western frontier for America's new government. Kenton was captured by Shawnee Indians in September 1778. A large man with great stamina, Kenton had survived a desperate episode five years earlier involving Indians in which he had nearly been killed. Left cold, barefoot and starving with two companions on the banks of the Ohio River, after having hidden for days from Indians who were pursuing them, Kenton and one of the other men were rescued by "long hunters" (the name

21

given to hunters who came to the West and stayed for extended periods of time).

This time, however, Kenton was alone and his capturers were intent on avenging the Indians who had been killed by Kenton and other Kentucky frontiersmen. Kenton's hands were bound and he was placed on a horse that was sent galloping through the woods, a scene recreated in a famous lithograph frequently shown in illustrated books about Kenton. Having survived this, Kenton was next forced to run the infamous quarter-mile gauntlet several times. Before run number five, while attempting to escape, Kenton had a hole hammered in his head; he remained unconscious for two days. The Indians later broke both his arm and collarbone. His captors called Kenton "one who is condemned to be burned at the stake," and on three different occasions he was tied to a stake and almost burned alive, but the Indians released Kenton so that they could continue to torment him.

Finally, the notorious renegade Simon Girty rescued Kenton and turned him over to the British in Detroit to be used for prisoner exchanges. In June 1799, Kenton made a daring and successful escape from Detroit back to Kentucky by completing a thirty-day march through hostile Indian territories. He continued his service with George Rogers Clark during the final years of the American Revolution, eventually becoming a frontier general.

In 1782, Kenton learned that he had not killed his boyhood rival back in Virginia and reassumed his given name. Although he would try various business ventures and lay claim to substantial tracts of land in Kentucky, Kenton was a notoriously poor businessman and ended up penniless and deeply in debt. Eventually, he moved his family to Ohio to begin anew. When he returned to Kentucky in 1820, he was arrested and thrown into debtor's prison. Kenton, who by now was a folk hero in Kentucky, was treated well by his jailers and released in December 1821 after the Kentucky legislature repealed the debtor's law. During these times, Kenton visited his old friend Daniel Boone in Missouri on four occasions and even considered joining Boone there. However, Kenton remained in Ohio until his death near Zanesville in 1836; he is buried in Ohio. Kenton's memorable contributions on the Kentucky frontier were recognized in 1840 when the newly formed county of Kenton in northern Kentucky was named for him.

Presley O'Bannon

1776–1850

"Yes sir, tell President Jefferson the marines can get the job done."
First Lieutenant Presley O'Bannon—United States Marine Corps—from Logan
County, Kentucky

F rom the halls of Montezuma to the shores of Tripoli"—those familiar
opening lines of "The Marine Corps Hymn" would not have been
written had Presley O'Bannon not been ordered to lead the marine
expeditionary force that defeated the Barbary pirates in 1805 in Tripoli.
Presley Neville O'Bannon was born in Virginia in 1776 and entered the
United States Marine Corps as a second lieutenant on January 18, 1801.
He served two tours of duty in the Mediterranean, where he witnessed the
continuous threats to western shipping from the Barbary pirates. While
serving on one of these tours he was promoted to first lieutenant. By 1802,
twelve American ships had been captured by the pirates, their goods seized
and the American crews shackled and cast into slavery. The U.S. Congress
had authorized construction of six frigates in 1794 (the birth of the American
navy) to deal with the problem, but the pirates were wily and difficult to
catch since they could slip into safe havens all along the North African coast.
After his election in 1801, President Thomas Jefferson declared the need to
protect American shipping from the Barbary pirates a high priority.

In 1805, General William Eaton asked Jefferson to give him one hundred
men to deal with the problem, but when none were made available, Eaton
turned to Marine First Lieutenant Presley O'Bannon instead. O'Bannon
was placed in command of a contingent of seven marines and four hundred
mercenaries. The force left Egypt in April 1805 and began an arduous three-
week, six-hundred-mile trek across the searing sands of the North African
desert toward the Barbary pirates' fortified stronghold at Derne in Tripoli.
After arriving there, and upon encountering stiff resistance from the city's
defenders, O'Bannon led a bayonet charge on the enemy's citadel, and the

bastion was taken on April 27. O'Bannon and his command stubbornly held the city against repeated attacks by the army of Tripoli until a treaty was signed in June 1805 ending the war.

"The Hero of Derne," as O'Bannon would come to be known, was awarded a jeweled Mameluke sword for his heroic acts by Hamet Karamanli, the legitimate sultan of Tripoli. The sword worn by all marine officers today is a replica of O'Bannon's original. The flag O'Bannon's command raised at Derne is believed to be the first American battle flag ever raised on foreign soil. Also, since marines during these times wore leather collars to protect themselves against sword slashes when boarding hostile ships, military personnel serving in the marine corps would come to be known as "leathernecks."

O'Bannon retired from the marine corps in 1807, after which he served two years as a captain in the U.S. Army. His regiment was disbanded in 1809, and he moved to Russellville, Kentucky, to join his mother, who had earlier moved there. He later served four terms in the Kentucky House of Representatives and two terms in the Kentucky Senate. O'Bannon died on September 12, 1850, and is buried atop a knoll in a cemetery in Frankfort, Kentucky, far, far away from the shores of Tripoli.

Jane Crawford

1763–1842

*"If the doctor lets that Crawford lady die, we're going to hang him
right here in his own front yard."*
*Jane Crawford—recipient of the first successful ovariotomy in the
United States—from Green County, Kentucky*

Jane Todd Crawford was born in 1763 in Virginia. She married Thomas
Crawford in 1794, and eleven years later the couple moved to Green
County, Kentucky, settling in a remote farming area located on the Blue
Springs Branch of the Caney Fork of Russell Creek. The closest hamlet
was Greensburg, and there were no surgeons in town at that time. In
1808, Jane's abdomen began to swell, and it appeared that she might be
pregnant with twins. Jane thought otherwise and wrote to Dr. Ephraim
McDowell, a prominent physician who lived in Danville, Kentucky.
McDowell had studied medicine at the University of Edinburgh's School
of Medicine in Scotland under some of the finest surgeons in the world.
He wrote back that if, as he thought, Crawford had an ovarian tumor, he
would be willing to operate, but there was a real danger of infection and she
might die.

Crawford resolved to take the chance. On or about December 20, 1809,
Jane, who was forty-seven at the time, mounted a horse and headed on the
dirt road for Danville, Kentucky, some sixty miles away. The journey was
arduous and the weather was cold, but this did not deter this strong-willed
pioneer woman from completing her journey.

Arriving in Danville, Crawford headed to Dr. McDowell's two-story
clapboard medical office located on South Second Street. McDowell's
examination of Crawford confirmed that she was not pregnant and that she
did have a large ovarian tumor that, if not removed, would certainly kill her.
Popular superstition of the times held that cutting into the body released
the body's "humors," and this should never be done. Nonetheless, since

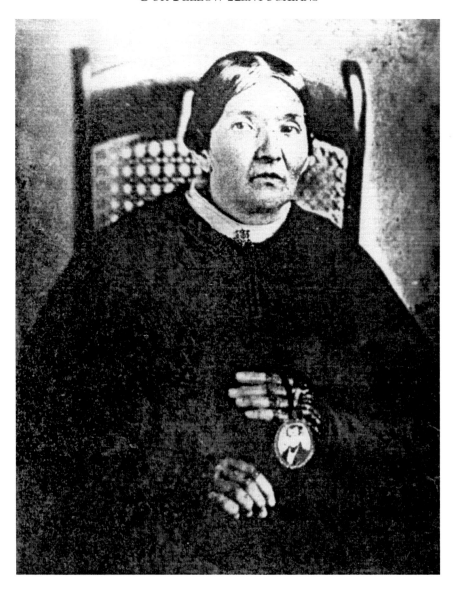

Jane Crawford. *Courtesy of the author.*

abdominal surgery was the only way to save Crawford, McDowell resolved to perform the operation, no matter what the risks.

It was Christmas Day, and word had spread that the doctor was going "to cut into the Crawford lady." A group of men were soon gathered in front of McDowell's office resolving to hang the doctor if the patient died. McDowell had other things to worry about. Anesthesia had not yet been

discovered, and he was about to perform an experimental and perilous operation. McDowell, aided by assistants who held Crawford's arms and legs down for twenty-five minutes, successfully removed a 22½-pound cystic ovarian tumor from the patient. McDowell later noted that Crawford, who was fully dressed and conscious throughout the operation, passed the time reciting Psalms.

Twenty-five days later, Crawford, who had recovered fully, mounted her horse and returned to her home in Green County. The operation, the first of its kind, established McDowell's reputation in the field of abdominal surgery, though he profited little from it. He did the same procedure eleven more times and only one patient died from it. McDowell, who passed away in 1830, would not be recognized as a pioneer in the field of abdominal and gynecological surgery until several years later. The hospital in Danville now bears his name, and his medical office and the brick apothecary he operated next door are historic sites. Jane Crawford died in 1842, a little over thirty-two years after her historic operation. The road that took a brave Kentucky woman to and from Danville, Kentucky, in 1809 (today a paved highway designated Kentucky Route 61) fittingly has been renamed the Jane Crawford Highway Trail.

Henry Clay

1777–1852

"Maybe the fifth time will be a charm."
Henry Clay—statesman and founder of the American Whig Party—from
Lexington, Kentucky

Henry Clay, U.S. senator under several presidents and candidate for president five times, was one of America's foremost statesmen of the pre–Civil War era. He is best remembered for his eloquent oratory, his ability to help strike compromises and his devotion to the Union. Henry Clay was born in Virginia in 1777. He overcame a rudimentary education and mastered the English language and then, in 1797, after completing a law degree in Virginia, moved to Lexington, Kentucky, to begin practicing law.

Clay was an early champion of the gradual emancipation of slaves, and in 1803 he was elected to the Kentucky legislature, where he served until 1806. He served briefly in the U.S. Senate from 1806 to 1807, during which time Clay first began enunciating a doctrine calling for federal funding for internal improvements of roads and canals, a cornerstone of a political doctrine subsequently termed the "American System." Later, Clay and the other supporters of his ideas expanded the American System by demanding that products made by American garment merchants be given preferential use over English woolens. In Kentucky, Clay's stance against English woolens provoked a bitter exchange of words in the Kentucky legislature with Humphrey Marshall, a prominent Federalist, and ended in a duel in which both men were wounded.

By 1810, Clay had returned to the U.S. Congress, first in the Senate and then in the House of Representatives, where he was elected Speaker in 1811, a position he held until 1824. Clay soon became the spokesman for a group in the House known as the "War Hawks"—men who favored the declaration of war against Britain in 1812. Clay was one of five men sent

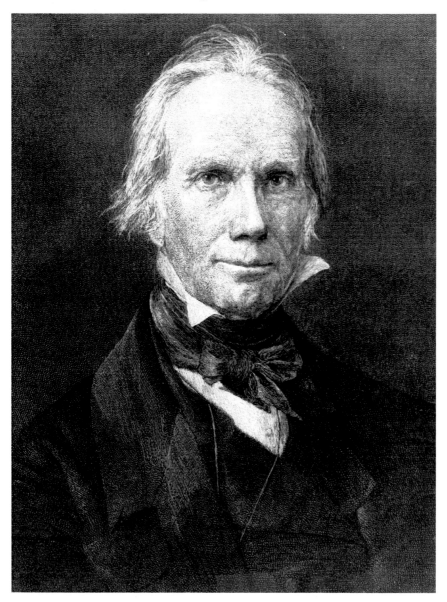

Henry Clay. *Courtesy of the author.*

to Ghent, Belgium, to negotiate the treaty signed there to end the war in 1814, and afterward he was reelected Speaker of the House. During the next four years, Clay supported establishing a protective tariff for American industry and creating a national bank, political components that Clay and his supporters added to the American System.

Clay's personal life was always taxing. He lived in Lexington, Kentucky, at Ashland, a stately house, where he and his wife cared for their eleven children. His many coach trips to Washington, D.C., over primitive roads were arduous and fatiguing, and his law practice was sometimes a financial disaster. Clay often failed to collect fees for his legal services and was "an easy mark" in money matters, cosigning on notes for his relatives that went unpaid and for which Clay was held financially responsible. Clay's well-known financial problems set him up for satirical abuse from his political enemies. A totally fabricated satirical song about Clay, entitled "The Unfortunate Man," portrayed him as having to marry a wealthy spinster to pay his debts and made fun of his skills as a lawyer for not securing the marriage's financial details with "a warranty deed," the nineteenth-century version of a prenuptial agreement. The supporters of Andrew Jackson, Clay's arch political rival, would gleefully break into choruses of this song whenever they were afforded an opportunity to deride Clay.

Clay's political career was also tumultuous. Lauded as the architect of the Missouri Compromise of 1821 (which helped define the rights of free blacks and mulattoes living in Missouri and clarified under what conditions Missouri might enter the Union as a slave state) and subsequently referred to as "The Great Compromiser," Clay ran unsuccessfully for president five times between 1824 and 1848. A staunch opponent of Andrew Jackson throughout Jackson's years as president, Clay helped found and headed the Whig Party, a coalition of Jackson's political opponents, in 1833. Clay's bitter feud with Jackson, his stance in favor of gradual emancipation of slaves—which would put Clay in opposition to the abolitionists—and the shifts of leadership within the Whig Party characterized the remainder of Clay's career. In 1842, Clay resigned his Senate seat to begin campaigning for president in the election of 1844, a contest he lost to James K. Polk by sixty-five electoral votes but by only thirty-eight thousand popular votes.

Clay's final effort to preserve his beloved Union occurred after he was returned to the Senate in 1849. In league with Senator Stephen A. Douglas of Illinois, Clay introduced a series of resolutions that became the basis for the Compromise of 1850, which again forestalled a showdown over slavery between the South and the North. Clay died in office while a senator on June 29, 1852, and was buried in Lexington, Kentucky. Few men have ever made such an impact on American history or led more conflicted lives than Henry Clay of Kentucky, one of America's true statesmen.

Kit Carson

1809–1868

"Yes sir, Mr. Frémont, I have scouted it out carefully, and all the
Indians around here are friendly."
Kit Carson—frontier scout and soldier—from Madison County, Kentucky

Christopher Houston "Kit" Carson, the son of Lindsay and Rebecca Robinson Carson, was born in 1809 in Million, a small hamlet located just outside of Richmond, Kentucky. After serving in the Revolutionary War, Lindsay Carson became a farmer. Seeking better farmland, he left Kentucky and moved his family to Franklin, Missouri, in 1811. The Carson family settled on a tract of land in Missouri belonging to the sons of Daniel Boone, and the Boone and Carson families soon became close friends. Lindsay Carson was killed by a falling tree when his son Kit was just eight years old, leaving the family in desperate poverty and forcing Kit to drop out of school and become a hunter to help feed his family.

At age fourteen, Carson was apprenticed to a saddle maker whose shop sat at the eastern end of the Santa Fe Trail. Fascinated by the tales of western adventures he heard from the trappers and traders who were clients of his employer, Carson quit his job and joined an expedition in 1826 heading west. His job was to tend to the horses, mules and oxen. In Taos, Mexico (modern-day New Mexico), the fur trade capital of the Southwest, Carson met an experienced trapper named Matthew Kinkead who took the young boy under his wing and taught him how to trap. Carson spent the years between 1829 and 1840 making his living by trapping; he would later describe these years as being the happiest of his life.

Carson married the first of three wives, an Arapaho whom he called Alice, in about 1836 and used his marital ties with Arapahos to persuade the tribe to allow him to trap unmolested along the Yellowstone, Powder and Bighorn Rivers. His second wife, a Cheyenne, left him to follow her tribe's migration, and his third marriage, a wise and politically astute union on

Carson's part, was to the Spanish daughter of a prominent Taos family. In 1842, while visiting old acquaintances in Missouri, Carson was introduced to Lieutenant John C. Frémont aboard a steamboat on the Missouri River. Frémont discovered that Carson possessed vast knowledge about the West and hired him to guide what would soon be known as the "First Frémont Expedition." Carson distinguished himself both as a guide and soldier during all three of Frémont's expeditions to the West (1843–45), well-publicized adventures that would make Frémont, who had been promoted to general, a serious contender for U.S. president in 1848 until he was court-martialed for disobeying a superior officer's orders.

Another thing credited with transforming Kit Carson into a popular national figure was the heroism he displayed in the Mexican War (1846–48). In December 1846, Carson crawled through enemy lines, walked barefoot thirty miles to San Diego in present-day California and helped organize the relief column for a small contingent of American soldiers trapped and surrounded by several hundred Mexican dragoons at San Pascal in California. This well-publicized rescue allowed General Kearny, the commander of the troops who had been surrounded, to gather reinforcements, escape from the trap and subsequently complete the re-conquest of California by American troops.

Between 1853 and 1861, Carson served capably as an Indian agent for the federal government in New Mexico. Tales about his many adventures while living on the frontier had begun to spread. He had trapped in the wilderness, led famed expeditions into uncharted territories, tracked down and killed renegade Indians, hunted and killed dangerous wild animals, married two Indians and one Mexican woman, befriended and served as a guide for a famous general and politician and distinguished himself as a soldier.

Carson resigned his post as a government Indian agent at the outbreak of the Civil War to take a commission as a lieutenant colonel in the Union army. As the commander of the New Mexican Volunteer Infantry, Carson directed actions against the Indians of the Southwest and was later promoted to general. After the war, he was placed in command of Fort Garland in Colorado but resigned this command in 1867 due to declining health. Carson died at Fort Lyon, Colorado, on March 23, 1868, and was buried in Taos, New Mexico. The legend of Kit Carson, which had commenced before he died, has grown through the years. Testimony to this are the many dime novels, poems, movies, television programs, songs and comic books that feature the various adventure tales associated with one of America's true folk heroes, Kit Carson, a Kentuckian who won fame on America's western frontier.

Jim Bowie

1796–1836

"Davy, ole buddy, how many Mexican soldiers did you say were out there?"
Colonel Jim Bowie—famous frontiersman who died at the Alamo—from Logan
County, Kentucky

The name Jim Bowie and the large-bladed weapon he always carried, the "Bowie knife," are each tied to the tales of conflict and adventure involving the men and women who carved out the early American frontier. Jim Bowie, who was born on the frontier in Logan County, Kentucky, in 1796, was the ninth of ten children born to Rezin Bowie and Elve Ap-Catesby Jones. The Bowies were a family constantly on the move, first settling in Georgia, then Kentucky, next in Missouri and finally moving to Louisiana in 1802.

As a young man, Jim Bowie learned to use a pistol, a rifle and a knife. Jim, who roped alligators out of the Louisiana bayous just for sport, was regarded by the locals as fearless, hot tempered and certainly the wrong man to agitate or to challenge to a fight.

Responding to General Andrew Jackson's call for volunteers to fight the British in the War of 1812, Bowie and his brother Rezin enlisted in the Louisiana militia in late 1814. However, the brothers did not arrive in time to participate in the decisive battle that Jackson fought against the British at New Orleans on January 8, 1815. After being mustered from the militia, Jim Bowie went into the lumber business in Louisiana, but the next call to adventure was too much for him to resist. In the summer of 1819, Bowie joined an American-led expedition attempting to liberate Texas from Spanish rule. Initially, the expedition was a success. Nacogdoches was captured, and Long, the leader of the expedition, declared Texas an independent republic. Once the scant fighting had ended, Bowie returned to Louisiana. Ironically, in so doing he missed the action he had craved as the Spanish returned and drove Long and his troops from the city.

Bowie and his brother's next adventure involved entering into land speculation and a slave trade scheme with legendary pirate Jean Lafitte. The prevailing law at this time in America prohibited the importation of slaves, but a provision in it allowed anyone who informed on a slave trader to receive half of the price that imported slaves would bring at auction as a reward. In league with Lafitte, the Bowie brothers made three trips to the pirate's compound on Galveston Island in 1818, smuggled slaves from there into Louisiana, turned themselves in and then claimed the reward. This scheme netted the Bowies $65,000 (some of which went to Lafitte), which they later used for land speculation in Louisiana.

Jim Bowie's life took an even more colorful turn in 1826. That year, Bowie was engaged in a confrontation with Norris Wright, the sheriff of Louisiana's Rapides Parish. Wright, who was enraged because Bowie was supporting Wright's opponent for sheriff, took a shot at Bowie but missed. Bowie then lunged at the sheriff, grabbed him and tried to kill him with his bare hands. Wright's friends intervened to stop the fight, after which Bowie resolved always to carry on his person a hunting knife he owned that measured 9.25 inches in length and had a blade 1.5 inches wide. Thus, the basis of the stories associated with Jim Bowie and the legendary knife he carried at his side, the Bowie knife, had accordingly been established.

A year later, on September 19, 1827, Wright and Bowie again stood facing one another on opposite sides, this time as witnesses to a duel. The duel was being held on a sandbar outside of Natchez, Mississippi. Two shots were fired, neither man was injured and the duel was concluded with a handshake. However, the real duel, in what has become known as "the Sandbar Fight," had not yet begun. A fight soon broke out between the opposing camps, and during the melee Bowie was shot in the hip. Bowie rose from the ground and charged his attacker with his knife, but the attacker clubbed Bowie over the head with an empty pistol, knocking him to the ground. At this point, Sheriff Wright shot at and missed Bowie, who then returned fire, possibly wounding the sheriff. Wright drew his cane sword, charged his stricken opponent and impaled Bowie. However, as Wright was trying to withdraw his sword from Bowie's chest, Bowie pulled the sheriff down and disemboweled Wright with his knife. Wright died instantly and Bowie, the sheriff's sword still protruding from his chest, was shot and stabbed again before the fight ended. This was the fight that cemented Bowie's reputation as a ferocious and dangerous man with a knife. Other fights would follow for Bowie, and each time he and his now famous knife prevailed. He would, however, lose his final battle, the one that cost him his life, at the Alamo.

Rascals, Heroes and Just Plain Uncommon Folk

In 1830, Bowie left Louisiana to become a permanent resident of Texas. Bowie, who was fluent in both Spanish and French, soon settled in a city known as Bexar. Most of the residents of Bexar were of Mexican descent, and Bowie, who was always looking for an edge, put his ability to speak Spanish and his reputation as a vaunted fighter to immediate good use. Based on his reputation, Bowie was elected a commander of the Texas Rangers a few months after arriving in Bexar. On September 30, 1830, he became a Mexican citizen. His new status as a Mexican citizen was his cue to return to land speculating, an enterprise that in Bowie's experienced hands resulted in him acquiring control of over 700,000 acres. Bowie next married the nineteen-year-old daughter of his business partner, who, certainly not by chance, just happened to be the Mexican vice governor of the province of San Antonio de Bexar.

Bowie's fate was sealed in 1835 after he decided to support William B. Travis, the leader of the War Party that was seeking to separate Texas from Mexico. When the Texian Revolution began in October 1835, Bowie, now a colonel in the Texas Rangers, was asked by Stephen F. Austin to scout Mexican positions prior to the first battle of the revolution, the Battle of Concepcion. In the fighting at this battle on October 28, 1835, a stalemate developed between the Mexican army and the "Texians," but Bowie rallied the troops under his command, charged and seized the Mexican cannons and carried the day for his side.

In 1836, Bowie was commanding a volunteer force in San Antonio when Major William Travis arrived with regular army troops. After a dispute over command (Bowie outranked Travis but did not hold a regular army commission), it was decided that the two men would share command defending a Spanish mission in the city, the Alamo. Bowie, however, had pneumonia and remained confined to his cot inside the mission throughout the fighting that ensued. The rest of the story—the fall of the Alamo and the death of all its defenders, including Jim Bowie, who died, it is said, fighting from his cot with knife in hand—is well known. Of such stuff legends are made, and the legend of Jim Bowie and his famous knife will most likely long endure.

Jefferson Davis

1808–1889

"I don't want to be the president of the Confederate States of America;
I just want to command the army."
Jefferson Davis—president of the Confederate States of America—from Davisburg,
Kentucky

A rallying cry among Union soldiers during the Civil War proclaimed, "We will hang Jeff Davis from a sour apple tree." Given their horrendous casualties and sufferings on the battlefield, such bitterness toward the leader of the Confederate government by Union soldiers is understandable. Yet, ironically, Jefferson Davis, the object of such intense hatred, had once been one of America's most famous military heroes as well as one of the nation's foremost statesmen.

Jefferson Finis Davis was born in 1808 on a farm in rural western Kentucky. His father, Samuel Davis, named the family's tenth and last child Jefferson for the contemporary president of the United States, Thomas Jefferson, whom Samuel greatly admired. Men in the Davis family, including Samuel Davis, had traditionally served their nation as army officers, some in the Revolutionary War and others in the War of 1812. By 1812, Samuel had relocated his family to Wilkinson County, Mississippi, where their precocious five-year-old son, Jefferson, attended a log cabin school. After two years, Samuel Davis was dissatisfied with his son's rudimentary education and sent him to study at a school run by Catholic priests in Washington, Kentucky, even though Jefferson was at the time the only Protestant enrolled.

Davis stayed two years in Kentucky, returned home and studied at a prep school in Mississippi. In 1821, at age thirteen, he was judged ready for higher education and entered Transylvania University in Lexington, Kentucky. He spent three years at Transylvania, where he was a popular student, often gaining acclaim both for his singing and speaking abilities. Davis's father, whose success as a Mississippi planter had placed him in

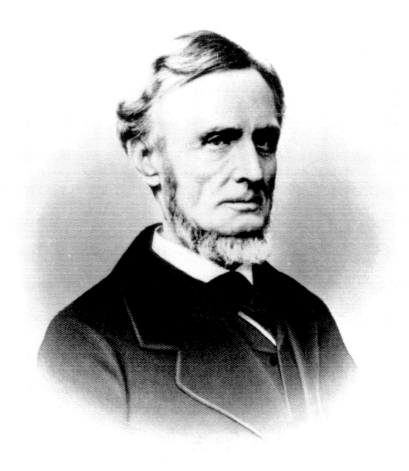

Jefferson Davis. *Courtesy of the author.*

contact with influential state and national politicians, used these political connections to secure his son an appointment in 1824 to West Point. Thus, in keeping with the tradition of males from his family serving as officers in the army, Jefferson Davis reluctantly left Transylvania, not having completed his senior year, and entered the military academy.

Davis, who ranked in the lower half of his class at West Point both academically and for discipline marks, was commissioned a second lieutenant upon his graduation in June 1829 and assigned to an infantry regiment in Wisconsin. His life in the army took its most interesting turn in 1832 when, while he was serving as an aide to another Kentuckian, future U.S. president Colonel Zachary Taylor, Davis met and fell in love with

Taylor's daughter, Sarah Knox Taylor. Since Taylor did not approve of the match, Davis resigned his commission, and on June 17, 1835, he and Sarah were married.

Tragedy soon struck the newlyweds. While they were visiting Davis's oldest sister at her plantation deep in the marshlands of Louisiana, both Sarah and Jefferson contracted malaria. Sarah died on September 15, 1835, just three months after the wedding, and in 1836, after his own difficult recovery, Jefferson Davis, inconsolable over the loss of his wife, moved to a plantation in Mississippi owned by his brother Joseph. Jefferson Davis spent the next eight years as a recluse, reading history, studying government and politics and engaging in private conversations about politics with his brother at the plantation in Mississippi.

In 1843, Jefferson Davis, by now somewhat healed and acting on his interest in politics, ran for a seat in the U.S. House of Representatives as a Democrat but lost to his Whig opponent. A year later, Davis ran again and was elected to serve in Mississippi's At-large District as a member of the House of Representatives. He entered the House on March 4, 1845, and in December married Varina Howell, the seventeen-year-old granddaughter of the late and greatly admired eight-term governor of New Jersey, Richard Howell.

In June 1846, just one month after fighting had begun between the United States and Mexico in the Mexican-American War, Davis resigned his House seat, returned home and raised a volunteer regiment, which he commanded as the regimental colonel. He insisted that his troops were to be armed with the new Whitney percussion rifles; because this was the first regiment to use them, the troops he commanded became known as the "Mississippi Rifles."

In a rather strange twist, Colonel Davis and his regiment were placed under the command of Davis's former father-in-law, Zachary Taylor, now a general. Any tensions that may have existed between Davis and Taylor were quickly set aside once the fighting began. In September 1846, the Mississippi Rifles participated in the siege of Monterrey, Mexico, where they used their new percussion rifles with particular effect against the enemy's infantry. Davis was seen on his horse commanding throughout the battle, urging his troops onward.

In February 1847, at the Battle of Buena Vista Ranch, Davis also played a major role in the American victory. Wounded in the foot early in the battle, with blood filling his boot, Davis stayed mounted in command until his regiment helped carry the day, after which he fainted and was carried to safety. It was later said that Davis had played a command role at the Battle of Buena Vista second only to the one played by Zachary Taylor, the

battle's commanding general. This point was confirmed when Taylor visited Davis's bedside later to recognize his bravery and initiative at Buena Vista and reportedly exclaimed to his former son-in-law, "My daughter, sir, was a better judge of men than I was!"

A national war hero, Davis returned to Mississippi and was appointed in December 1847 by the state's governor to fill a U.S. Senate seat left vacant by a death; he was elected to serve the rest of the term in January 1848. Jefferson Davis chaired the Senate Committee on Military Affairs from 1849 until 1851, after which he resigned his Senate seat to run for governor of Mississippi, a race he lost by only 999 votes. Out of office but still politically involved, Davis campaigned in several southern states on behalf of Franklin Pierce, the Democratic candidate for president in 1852. After his election, President Pierce made Davis the secretary of war. Davis's most important work in this post involved a report he submitted to Congress detailing various routes for the proposed Transcontinental Railroad.

Davis resigned his cabinet post to run for the Senate in Mississippi after the Democrats selected James Buchanan as their presidential candidate in 1856 rather than Pierce. Davis won the election and reentered the Senate on March 4, 1857. The next four years of Jefferson Davis's life would be history making as first he struggled to preserve the Union and then headed the government that opposed it. During the first year of his term in the Senate, Davis was quite sick, suffering from an illness that nearly cost him his left eye. On July 4, 1858, Jefferson Davis, one of the nation's most influential Southern senators, while sailing on a boat in waters just outside of Boston, delivered a powerful anti-secessionist speech that captured headlines nationally. Three months later, in another speech at Boston, he eloquently reiterated his position by urging all parties concerned to join together to help preserve the Union.

Davis, like his Southern colleagues in Congress, believed that states had the rights to secede from the Union, but he believed doing so would be both a serious mistake and a national tragedy. Lincoln's election as president in November 1860 placed the nation at the brink of war. Davis was now conflicted by the realities of Lincoln's election and his understanding of what results might lay ahead. As secretary of war under Pierce, Davis had become convinced that the Southern states did not have the military and naval resources to defend themselves. But war was looming eminent in the spring of 1861 and Jefferson Davis was once again to become a reluctant victim of his Southern heritage.

South Carolina's departure from the Union in December 1860 set the stage for ten other Southern states, including Davis's home state of Mississippi, to secede. Davis's last speech before his departure from the Senate was a

summation of a life now entangled by forces seemingly beyond any one individual's control. As he rose to bid his farewell, Davis delivered what was perhaps his finest speech. They were words spoken from the heart, a speech that spoke of his love for his country, of his military service and of the personal sadness he felt because of the Union's fragmenting. When he concluded, there were many wet eyes on the Senate floor as well as audible weeping in the galleries. Even the Senate's grim-faced Republicans seemed to understand that this was a man who loved his nation more than they had ever suspected.

Davis's four years as president of the Confederacy (1861–65) were controversial. Perhaps he would have been better posted as a general in command of an army. Who can say? His supporters in the South revered him as a tragic statesman swept away by forces beyond his control. His detractors, both in the North and the South, slandered and maligned him as being weak and ineffective. He survived the war, was captured, charged with treason, imprisoned for two years and then was set free in 1869. In his later years, Davis traveled abroad extensively and in 1881 completed a two-volume book entitled *The Rise and Fall of the Confederate Government*.

In October 1889, Davis's *Short History of the Confederate States of America* was released. Both of his books remain standard source materials concerning the history of the American Civil War. He died in New Orleans on December 6, 1889, of unknown causes, at age eighty-one. His body was taken from New Orleans for burial in Richmond, Virginia, by continuous day and night cortège, producing a funeral said to have been one of the largest ever seen in the South. The South is dotted with memorials to Jefferson Davis, but perhaps the most impressive stands near Davis's birthplace just outside of Fairview, Kentucky, a two-hundred-foot obelisk paid for entirely by private donors.

Abraham Lincoln

1809–1865

"I certainly would like to have God on my side, but I must have Kentucky."
Abraham Lincoln—president of the United States of America (1860–65)—from
Hodgenville, Kentucky

Abraham Lincoln declared at the beginning of the Civil War in 1861 that to stem the tide of secession in the South and to preserve the Union, he must have the state of Kentucky. His meaning was clear, and for the next two years Lincoln and Unionists in the state did everything, legal or otherwise, to ensure that Kentucky, a strategic military gateway to both the North and the South, remained a part of the Union. Abraham Lincoln, the son of Thomas and Nancy Hanks Lincoln, was born in modern-day Larue County, Kentucky, on the north fork of the Nolan River in 1809. His father was a farmer, and like so many of the families living on the frontier of America the Lincolns would move from time to time seeking better farmlands. Thomas Lincoln was opposed to slavery and decided to move his family across the Ohio River to get away from it. In 1816, when Abraham was seven, his family moved to a site along the Little Pigeon Creek in southern Indiana, and then a few years later the Lincolns moved to Illinois.

Abraham Lincoln's ties to Kentucky, however, remained deep. His wife, Mary Todd Lincoln; his law partners in Illinois; his closest friend, Joshua Speed; and his political mentor, Henry Clay, were all from Kentucky. On occasion, Lincoln returned to Kentucky to visit his in-laws in Lexington or to spend time with the Speeds, who resided at a large estate, Farmington, located just outside of Louisville. It's little wonder that Lincoln understood Kentucky's strategic importance as well as that of the Ohio River, which flowed for over six hundred miles along Kentucky's border.

Lincoln, a Henry Clay Whig turned Republican, was elected president of the United States in 1860. He became the man who helped split the Union and the one who helped preserve it. Lincoln's election was the red flag that drove

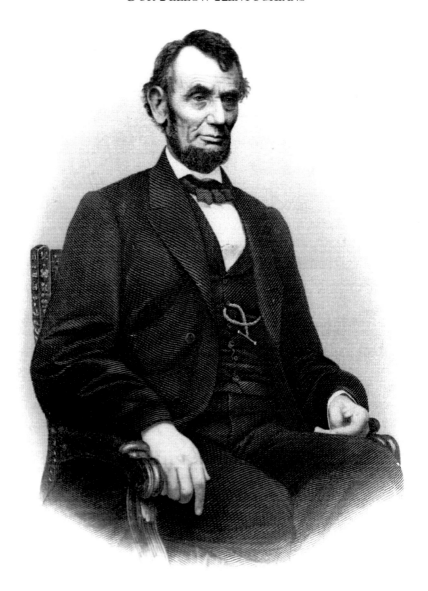

Abraham Lincoln. *Courtesy of the author.*

the South to secession and violence. Confident that their cause was just and their fighting men were superior to those of the North, the military forces of the newly constituted Confederates States of America fired upon the Federal installations at Fort Sumter, South Carolina, on April 12, 1861, thus starting the American Civil War. Lincoln immediately issued a Federal call to arms to state militias calling for seventy-five thousand men. Kentucky's militia was part of

the quota Lincoln had set, but Kentucky's governor, Beriah Magoffin, refused to honor Lincoln's call for troops, declaring that he would "send not a man nor a dollar for the wicked purpose of subduing my southern sister states."

The seeds of rebellion in Kentucky had been planted by Governor Magoffin, and Lincoln and the Unionists in Kentucky moved rapidly to see that they were not allowed to grow and spread. In the special congressional elections held in Kentucky in June 1861 Unionists won nine of ten seats, the lone exception being a district in far western Kentucky. Two months later, the Unionists captured a two-thirds majority in the Kentucky General Assembly and elected strong supporters of the Union to leadership positions in both the House and Senate. Meanwhile, Magoffin had declared Kentucky a neutral state, but neither the Confederacy nor the Union paid this any heed.

Confederate military forces moved into Kentucky in the fall of 1861, violating the state's neutrality, and Lincoln armed the state's pro-Union Home Guards with several thousand rifles dubbed "Lincoln guns." The Union also established a recruiting camp in central Kentucky at Camp Dick Robinson near the Dix River. There would be several hundred minor military actions in Kentucky during the Civil War but only one major battle, the Battle of Perryville in October 1862. That battle was in response to a Confederate invasion of Kentucky that threatened to place the state into Confederate hands. However, the invasion was blunted and turned back at Perryville. Other than raids by Kentuckian John Hunt Morgan and other Confederate mounted raiders, nothing of military significance took place in Kentucky for the remainder of the war. During one of Morgan's raids into Kentucky a concerned Lincoln telegraphed his commanders that a stampede was taking place in Kentucky and asked them to please look into this matter at once.

The Union's military triumphs in Kentucky were paralleled by Unionist political victories. In August 1862, Governor Magoffin resigned and was replaced by a pro-Union governor, and the powerful Unionist head of the State Senate was reelected to his post. Nonetheless, at times, with about one-third of Kentucky's population pro-Southern, the rights of Kentucky citizens were violated either by the use of martial law or by the illegal confiscation of their properties.

Though a native son, Lincoln was never popular politically in Kentucky. When Lincoln ran for president in 1860, he finished fourth in a four-man field, receiving only 1,364 votes statewide. Even some members of Lincoln's own wife's family in Lexington, the Todds, were hostile toward Lincoln; some of them, in fact, would die while fighting with the Confederate army. On one occasion, Lincoln, shunned by his aristocratic in-laws, reportedly proclaimed, "The Todds need two d's in their name, and God Almighty only needs one!"

Another defining moment with regard to Lincoln's association with Kentucky came when he issued the Emancipation Proclamation in January 1863, freeing the slaves in all the seceded states. Kentucky, though divided in its loyalties, had remained in the Union. Still, up to three-quarters of the slaves in the Commonwealth of Kentucky were already freed or had fled to freedom by 1863, and the remainder would be freed in 1865 by the ratification of the Thirteenth Amendment. The issue that followed was that if slaves were defined as property, as they had been before the war, then the property rights of Kentucky slaveholders had been overridden by political actions and no compensation had been offered them. The bitterness that this created played out in two ways as later Kentuckians filed lawsuits asking for financial restitution but never received any, and immediately following the war, Kentuckians generally supported Democrats, many of whom had fought for the South. A clear view of the political future in Kentucky came during the presidential election of 1864, in which Lincoln, at the highpoint of his presidency, lost Kentucky, winning only 28 percent of the votes cast.

Lincoln's assassination in 1865 left it unclear how Kentucky might have fared in a Lincoln-led postwar era. Many Kentuckians soon came to view the Civil War as a tragedy that had divided both the nation and their state. Many citizens living in central Kentucky and parts of western Kentucky romanticized the war, believing that the Confederacy had fought for a noble cause but lost. Most of the citizens living in the northern and eastern parts of Kentucky either had stood firmly with the Union or had stayed benevolently neutral.

The real question that needs to be asked is what would Lincoln's legacy be to Kentucky? In general, Lincoln's stature grew as time passed. Kentuckians came to honor their native son's difficult role as protector of the Union and mourned his tragic end. On February 9, 1909, one hundred years after Lincoln's birth, a commemorative ceremony was held at Hodgenville, Kentucky, near Lincoln's birthplace. Kentucky's Republican governor, Augustus E. Willson, made it clear to the crowd assembled that Lincoln should be remembered and honored foremost as being a Kentuckian. First recognizing that Lincoln was claimed by the entire nation, Willson observed that some states had special claims to Lincoln when he said,

> *Illinois says He was mine, the man of Illinois, here on my prairies he ripened into noble manhood and here he made his home. Indiana says He was mine. In my southern hills the little child grew strong and tall. While each is true, Kentucky surpassed both because it could say, I am his mother, I nursed him at my breast, my baby born of me. He is mine. Shall any claim come before the Mother?*

Cassius Marcellus Clay

1810–1903

"Look here, sheriff, her brother said it would be all right."
Cassius M. Clay—ex-slaveholder who became a spokesman for the emancipation of
slaves—from Madison County, Kentucky

Cassius Marcellus Clay (the name shared by the boxing champion later known as Muhammad Ali) lived a life as controversial as it was colorful. Characterized by a biographer as being the "Firebrand of Freedom," he was born on a plantation near Richmond, Kentucky, the son of General Green Clay and Sallie Lewis Clay. General Clay, a successful politician and capable American commander during the War of 1812, was one of the richest men in Kentucky, having accumulated over forty thousand acres of Madison County farmland as well as owning a number of slaves, gristmills, distilleries, toll roads, a resort and two large warehouses.

Cassius Clay would become one of Kentucky's most prominent and controversial political figures. Educated at Transylvania University in Lexington, Kentucky, and later at Yale University in Connecticut (where he came under the influence of leading abolitionist William Lloyd Garrison), Cassius inherited the family's Madison County plantation and sumptuous house, White Hall, in 1832. Just twenty-two at the time, Clay immediately freed his slaves and dove into politics as a Whig, favoring the so-called American System of internal improvements for roads and canals, protective tariffs, promotion of American-made goods and products and support for a national bank, all policies enunciated by Clay's cousin, Whig Party leader Henry Clay.

Never shy about expressing his opinions, Cassius's outspoken stance against slavery alienated the proslavery supporters within the Whig Party in Kentucky, and on one occasion this led to a duel in which neither he nor his opponent, Kentuckian Robert Wickliffe Jr., was injured. Two years later, Clay stabbed and nearly killed a man who had attempted to assassinate

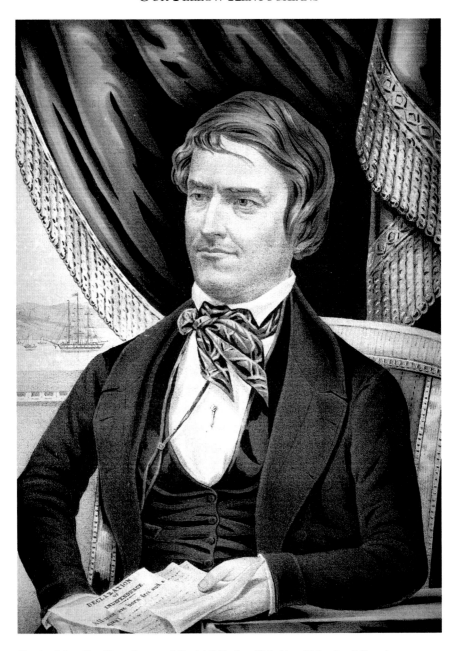

Cassius Marcellus Clay. *Courtesy of Special Collections & Archives, University of Kentucky.*

him at a political rally in Kentucky. Cassius Clay campaigned throughout the North in 1844 for Henry Clay in his cousin's unsuccessful bid for the presidency. A year later, Cassius began publishing an antislavery paper in Kentucky, the *Lexington True American*. While Clay was lying ill with typhoid fever, a posse that included Clay's son, James B. Clay, went to the newspaper office, dismantled the press and shipped it off to Cincinnati. For a short time, Clay continued publication of his paper in Cincinnati.

Clay next served as a captain in the Mexican War, after which he returned to Lexington and continued to agitate against slavery. Putting his money where his mouth was, so to speak, Clay deeded ten acres of land in Madison County to fellow Kentuckian and abolitionist preacher John Fee, who used it to found Berea College, a school designed to help forward the cause of abolitionism in the upper South. Clay next became a Republican, campaigning vigorously for that party's candidates in the 1856 elections. Although Clay was mentioned in 1860 as being one of the nine potential Republican candidates for president, he threw his support behind Kentucky-born Abraham Lincoln. After being elected president, Lincoln made Clay minister to Russia.

Clay spent two years serving in Russia before being recalled by Lincoln in 1862 and being made a major general in the Union army. This appointment was political in intent, not military. Lincoln instructed Clay to return to Kentucky and to ascertain if loyalists in the state would support a proclamation freeing the slaves. Clay returned to Washington and reported that the loyalists were firmly behind Lincoln; on January 1, 1863, Lincoln issued the Emancipation Proclamation freeing the slaves in the seceded states of the South and, in effect, in Kentucky as well, even though Kentucky was not one of the secessionist states.

In 1863, Clay returned to Russia as minister. In January 1862, during his first posting to Russia, Clay's wife had left and returned home to care for their children. When Clay returned to Russia in 1863, she refused to come with him. Clay was lonely, but not for long. Rumors abounded that Clay, who was wealthy, dashing and in the prime of his life, had many romantic liaisons during these years in Russia. At least two well-known Russian ballerinas were said to have been Clay's paramours, and one, Anna Petroff, likely bore him the son Launey (Leonide Petroff) Clay, whom Clay later brought to Kentucky as his "adopted" son.

Clay greeted the assassination of Lincoln, a man with whom he had had a close affinity, with rage, but far removed from America there was nothing he could contribute to ease the political conflicts that soon erupted between Lincoln's successor, Andrew Johnson, and the Senate's Radical Republicans.

William Seward, who would serve in both Lincoln's and Johnson's cabinets, had always disliked Clay, and as Johnson's secretary of state, was content to see him remain in Russia, where Clay would remain as minister until 1869. Clay involved himself in politics after returning home, often speaking out against the Radical Republicans while politicking in the South in favor of the Democrats who opposed them.

White Hall, Clay's ancestral home near Richmond, Kentucky, was the scene of the last great drama of his life. At age eighty-three, Clay divorced Mary Jane, his wife of forty-five years and the mother of their ten children, to marry the orphaned fifteen-year-old sister of his tenant farmer. "The Lion of White Hall," as Clay was known to locals, had stepped over the line with regard to community sensibilities. The local sheriff and a posse of seven men came out to persuade Clay that what he had done was wrong and that he needed to correct the problem. The old fighter was ready for them. He had filled an antiquated single-bore cannon he owned with nuts, bolts, broken horseshoes, nails and an assortment of other sharp pieces of metal and awaited their approach. When the sheriff and posse showed up, they took cover behind a dried-up willow tree in Clay's front yard, but to no avail. Clay lit the cannon's fuse and unleashed a mighty fuselage on his adversaries, scattering them to the wind, licking their wounds, never to return. Clay's new wife, Dora Richardson Clay, divorced him after just one year of marriage. Cassius Marcellus Clay was demonstrably "a one-of-a-kind" and we may never see his likes again.

Henry Stanberry

1803–1881

"I advocate to this body emphatically that President Andrew Johnson is not guilty, and I intend to prove it."
Henry Stanberry—attorney general of the United States under President Andrew Johnson—from Fort Thomas, Kentucky

Henry Stanberry, who resided for many years in Fort Thomas, Kentucky, was thrust upon the stage of history by a bizarre set of circumstances. Stanberry was an experienced lawyer with impressive credentials when President Andrew Johnson appointed him attorney general of the United States in 1866. Stanberry had earlier been made the first attorney general of Ohio in 1846 and participated in the drafting of Ohio's constitution in 1851. After serving as Ohio's attorney general, Stanberry moved to Cincinnati, where, in 1853, he returned to the private practice of law. One year later, he moved across the Ohio River to the nearby District of the Highlands in Kentucky. In 1866, Stanberry drafted the paperwork of incorporation to convert that district into the city of Fort Thomas, Kentucky.

Initially a Whig, Stanberry switched to the Republican Party when his former party was dismantled during the 1850s. After the Civil War, he was drawn into the political conflicts and controversies surrounding Andrew Johnson's presidency. Johnson, a southern Democrat who supported the moderate policies of healing and reconstruction that had been advocated by the assassinated president, Abraham Lincoln, clashed throughout his term in office (1865–69) with the Radical Republicans in the Senate who were determined to punish the South. When Johnson's first attorney general, James Speed, resigned in 1866 because he could no longer support Johnson's policies, Henry Stanberry was thrown into the political fires as Speed's replacement.

President Johnson had first taken note of Stanberry's abilities in 1866 while Stanberry represented the federal government in its successful defense

against allowing military courts to preempt civil courts and to suspend a citizen's right of habeas corpus. Although nominated by Johnson in 1866 for the Supreme Court, Stanberry was left hanging on this matter when the Senate refused to act on his nomination. Instead, fearing that a Johnson court nominee would support the president's moderate reconstruction policies, the Senate voted to reduce the number of justices from ten to seven, thereby depriving Johnson of the ability to appoint new justices during his presidency.

Nonetheless, Stanberry and Johnson soon became a powerful alliance consistently thwarting attempts by Senate Radical Republicans to introduce new stringent policies toward the South. When Johnson was impeached by the Senate in 1868, Stanberry resigned his office and readied himself to defend the president. Despite the fact that Stanberry was sixty-three years old and quite ill throughout the impeachment proceedings, he mounted a brilliant defense, much of which had to be delivered to the Senate in writing. Stanberry was even too sick to attend and witness the high drama of Johnson's acquittal in the Senate chambers by a single vote.

Afterward, when Johnson tried to reappoint Stanberry as attorney general, the Radical Republicans in the Senate, smarting from their loss, blocked the reappointment. After having helped preserve Johnson's presidency, Stanberry remained in Washington for the next few years, often arguing on strict constitutional grounds cases that challenged the government's criminal prosecution of the Ku Klux Klan. In the mid-1870s, Stanberry returned to his home in Fort Thomas, where he briefly served as president of the Cincinnati Bar Association. Afterward, he devoted his time to managing his substantial property holdings in Fort Thomas and writing about political and legal subjects. Henry Stanberry died in New York in June 1881.

In a sense, Stanberry's role in fashioning the successful defense of Andrew Johnson's presidency remains only a sidebar to the higher drama that saw that presidency so narrowly preserved. In their recounts, historians most often have focused on the deciding vote cast by an ailing senator from Kansas to sustain the president. But as popular radio commentator Paul Harvey might have concluded, it is only after one understands the role played by Henry Stanberry in these events that one can actually understand and appreciate the rest of the story.

Judge Roy Bean

circa 1825–1903

"First you fine them, and then you hang them."
Roy Bean—American western frontier's famed hanging judge—from Mason County,
Kentucky

Phantly Roy Bean was the youngest of three sons born to Phantly and Anna Bean, a poor farm family from Kentucky. Roy Bean left Kentucky as a teenager, hitching a ride on a flatboat bound for New Orleans. There he joined his two older brothers, who had come to Louisiana seeking adventure. The Bean brothers crossed the Rio Grande and set up a trading post in Chihuahua, Mexico, in 1848. Shortly thereafter, Roy Bean shot and killed a Mexican desperado who had bragged that he was going to kill a gringo at the trading post. Bean and his older brother, Joshua, then fled Chihuahua, and by spring 1849 they had settled in San Diego, California, where, in 1850, Joshua was elected that city's first mayor.

A ladies' man, Roy Bean was in and out of trouble involving women during these years. On one occasion he even fought a duel over a woman, wounding his opponent, which landed both men in jail charged with intent to commit murder. More troubles over women ensued. In 1854, Bean killed a Mexican army officer who had kidnapped Bean's latest girlfriend and forced her into marriage. Six of the dead soldier's comrades tried to hang Bean by leaving him with his hands tied, sitting on a horse with a noose around his neck. After the six men left, the officer's reluctant bride, who had been hiding nearby behind a bush, rescued Bean, but he was left with permanent rope burns on his neck and chronic neck pains. One can only speculate how much this experience later influenced Roy Bean once he became "the hanging judge" and "the Law West of the Pecos."

Bean failed at a succession of businesses before finding success by opening a saloon during the late 1870s in a slum-ridden Mexican town called Beanville. By spring 1882, he had moved his saloon business to the small tent

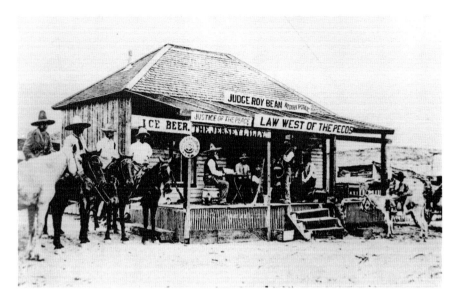

Judge Roy Bean's saloon. *Courtesy of the Library of Congress.*

city of Vinegaroon near the Pecos River because over eight thousand rail workers were working within twenty miles of this site. The nearest court was two hundred miles away. At the suggestion of a Texas Ranger that a local law jurisdiction be established, Roy Bean, who had no legal training but was highly visible as the town's popular saloonkeeper, was appointed justice of the peace for the area on August 2, 1882.

Bean used a single law book, the 1879 edition of the *Revised Statutes of Texas*, to dispense his own special brand of justice. Customarily, juries in Bean's court were made up of his regular saloon customers, and the jurors were expected to buy a drink during every court recess. Bean was notorious for his crazy rulings and his habit of first fining and then sometimes hanging the accused, deservedly so or not. By December 1882, railroad construction in the area had moved farther westward so Bean moved his courtroom and saloon seventy miles west to Strawbridge, Texas. Always the romantic with regard to women, Bean had become obsessed with contemporary actress Lilly Langtry, whom he had never even met. He changed the town's name from Strawbridge to Langtry in her honor and christened his saloon, which had a picture of the actress above its bar, "the Jersey Lilly." Langtry had no jail, so the justice Bean dispensed was certain to be either a fine, death by hanging or both. For weddings, Bean, who had had more than his fair share of women troubles, charged five dollars and ended each ceremony with, "And may God have mercy on your souls."

Bean, who remained Langtry's justice of the peace until 1896, gained fame nationwide in 1896 when he organized a world championship boxing match between Bob Fitzsimmons and Peter Maher that was held on a sandbar in the Rio Grande, since boxing matches were illegal in Texas. Bean mellowed after ending his work as judge, spending much of his time and wealth helping the area's poor. He died on March 16, 1903, in a drunken state in his own bed, and was buried at Whitehead Museum in Del Rio, Texas, along the Mexican border. The Texas gravesite of Roy Bean, one of the Old West's most legendary judges, has now become a tourist attraction.

Jack McCall

1852/53–1877

"I'm the man who made aces and eights the dead man's hand."
Jack McCall—man who shot and killed James "Wild Bill" Hickok—from
Louisville, Kentucky

Jack McCall, who stepped onto the stage of history by killing James "Wild Bill" Hickok, one of the Old West's most famous personages, was born in Louisville in either 1852 or 1853. His mother was a housekeeper at Louisville's Merchant's Hotel, and his father is believed to have worked on Ohio riverboats. McCall was raised by his three sisters but drifted west to the Kansas-Nebraska border, where by about 1869 he was working as a buffalo hunter. He next worked in Wyoming, after which, in 1876, he showed up in Deadwood, South Dakota, using the name Bill Sutherland, one of several aliases he assumed during his lifetime.

McCall, who was nicknamed "Crooked Nose" Jack, was a notorious drunk, a scoundrel and was said to have been stupid as well. He had chestnut hair, a small sandy moustache, a double chin and crossed eyes. On August 1, 1876, soon after his arrival in Deadwood, McCall sallied up to the bar at Nutall and Mann's No. 10 Saloon and proceeded to get drunk. A poker game was going on just across the way from the bar, and McCall wandered over to watch Bill Hickok, who was one of those playing cards. After one of the players quit, McCall took the open seat and played so poorly that he lost all of his money. Hickok gave McCall some money to buy something to eat and advised him not to play poker again.

McCall accepted the money but considered the gift an insult. The next afternoon, Hickok returned to the saloon to play poker but found his regular seat taken. After hesitating, Hickok took a seat with his back to the door and the bar, something he had vowed he would never do. It proved to be a fatal mistake. Across the way, McCall was again drunk at the bar. Still furious and believing Hickok had insulted him the day before, McCall shot Hickok in

the back of the head with a double-action .45-caliber revolver, exclaiming, "Take that!" Hickok fell dead to the floor, his poker hand of aces and eights (soon to be dubbed the "dead man's hand") tumbling down beside him. McCall tried to escape town by stealing a horse hitched up outside the saloon, but the saddle had been loosened and he fell to the ground. He took refuge in a butcher shop nearby but was soon apprehended.

McCall was tried by a hastily convened "miners' court" the next day at the McDaniels/Langrishe Theater. He claimed that he had killed Hickok to avenge the killing of his brother back in Abilene, Kansas, and after less than two hours of deliberation, McCall was found "not guilty." McCall, however, had never had a brother and therefore had lied at his trial. A few days later, McCall was told that hanging around Deadwood might be "bad for his health" so he struck out again for Wyoming. Proud of what he had done, McCall continued to get drunk and boasted loudly that he had killed Wild Bill Hickok. He was arrested on August 29 by a U.S. deputy marshal in Laramie, Wyoming, charged with murder and transported to Yankton, South Dakota.

Since Deadwood was located in Indian territory, the judge at McCall's trial noted that he was being tried legally for the first time and therefore was not protected by double jeopardy. Wild Bill's brother, Lorenzo Butler Hickok, journeyed from Illinois to attend the trial, which opened on December 4, 1876. Two days later, McCall was found guilty and sentenced to death by hanging. He was hanged on March 1, 1877, becoming the first man legally executed in the Dakota Territory. McCall, who had requested that a priest be with him before the hanging, was buried in Yankton's Catholic Cemetery. In 1961, his body was exhumed when the cemetery was being moved to make room for a hospital, and it was discovered that McCall had been buried with the noose still tied around his neck.

Nancy Green

1834–1923

"I love her smile, but I love her pancakes even more."
Nancy Green—original Aunt Jemima—born into slavery in rural northeastern Kentucky

Nancy Green, an emancipated slave from Montgomery County, Kentucky, became one of America's best-known corporate symbols when, in the early 1890s, she was employed by a Chicago flour company to portray a stereotypical black cook named Aunt Jemima. In 1889, Chris Rutt and Charles Underwood of the Pearl Milling Company in Illinois developed a product they called Aunt Jemima (the first ready baking mix) and founded a business known as the Aunt Jemima Manufacturing Company.

Chris Rutt had come up with the name Aunt Jemima after hearing a song by that name performed by two blackface minstrel entertainers, Baker and Farrell, who sang it wearing an apron and kerchief appropriate to the character. In 1890, R.T. Davis purchased the struggling Aunt Jemima Manufacturing Company. Davis, a clever marketer, immediately started searching for an African American woman to portray a Mammy archetype and to promote the Aunt Jemima ready-mix flour brand. He found Nancy Green, just the person to play the part. Green had a robust wholesome look, was the right size in height and weight and had distinctive and strong facial features that photographed well. She was also outgoing, a gifted storyteller and, as a bonus, was a good cook. In short, Green and the Aunt Jemima advertising caricature she was called upon to portray were the perfect fit.

Davis used the opening of the World's Columbian Exposition in Chicago in 1893 as the moment to introduce his flour brand's new spokeswoman to the public. Posing before what the Davis Milling Company advertised as "the world's biggest flour barrel," Nancy Green, costumed as Aunt Jemima, became the exposition's hit attraction. Smiling and greeting guests, Green captivated audiences with her singing and storytelling while helping to dispense mouth-watering ready-mix Aunt Jemima pancakes. In recognition

Nancy Green, as the original Aunt Jemima. *Courtesy of the author.*

of the Aunt Jemima exhibit's popularity, Green received a medal and a certificate from expo officials. It was later reported that the Davis Milling Company sold one million pancakes to visitors at the show.

Green, the first of seven African American women to portray the Aunt Jemima character, spent over thirty years as the live spokesperson of a corporate product line that grew to include a variety of syrups, buttermilk pancake and waffle mixes and frozen lines of waffles and French toast. She toured the world making hundreds of public appearances, remaining ever true to the character she portrayed. Green, who was known for her charitable activities and good-heartedness, was never highly paid, nor were her successors. Green spent most of her extra money promoting anti-poverty programs in America's poorest African American communities, bristling

at any suggestions that her role as Aunt Jemima was an insult to her race. Green remained employed as the Aunt Jemima corporate symbol by Davis Milling until her death in 1923.

The Quaker Oats Company purchased the Aunt Jemima brand name in 1926 and reintroduced the Aunt Jemima character at the 1933 World's Fair in Chicago. Over the years, Quaker Oats has relied upon a combination of live appearances by the women employed to portray Aunt Jemima, radio and television ads and catchy jingles to expand the brand's market. In 1989, the image of Aunt Jemima was updated by giving her pearl earrings; her headband was removed. Today, the trademark image of Aunt Jemima appears on products that annually earn more than $350 million. The image of Aunt Jemima is that of a humble cook, ever cheerful and smiling, the indisputable master of the household kitchen. It is altogether fitting that Nancy Green, born a slave in Kentucky, overcame all adversities and can still be commemorated as having been the original Aunt Jemima, the advertising icon that has now lasted for over a century.

Ralph Waldo Rose

1884–1913

"This flag dips to no earthly king."
Ralph W. Rose—Olympic champion in track and field—from Louisville, Kentucky

It is rather unusual that a man who only lived to age twenty-nine could leave a significant historic mark that has endured the test of time, but for Olympic champion Ralph Waldo Rose, such was the case. Ralph W. Rose was born in 1884 in Louisville, Kentucky. Soon thereafter his parents moved to California, where Ralph was raised. After graduating from Healdsburg High School in northern California, Rose attended the University of Michigan for a time. He then returned to California, studied law and was admitted to the bar.

Ralph Rose, who was six feet, five and a half inches tall and competed at weights ranging between 250 and 280 pounds, was America's premier track and field athlete in the opening years of the twentieth century. In 1904, while at the University of Michigan, he won the Big Ten championships in both the discus and shot. At the Summer Olympics held in St. Louis, Missouri, in 1904, Rose won the gold medal in shot put, silver medal in discus throw, bronze medal in hammer throw and was sixth in the 56-pound weight throw.

Because of his achievements in St. Louis, Rose was selected to carry the American flag at the opening ceremonies of the 1908 Summer Olympics held in London, England. The American team, coaches and most everyone else, for that matter, were in for a surprise. Rose was Irish in ancestry and was close friends with a number of other American Olympians who were of Irish descent. The ancient and bitter struggles between England and Ireland were not far from their minds. Accordingly, Rose, heading the parade of American athletes who passed by Edward VII, the king of England, broke tradition and refused to dip his country's flag to the English king. Martin Sheridan, another Irish-American Olympian, is reputed to have later

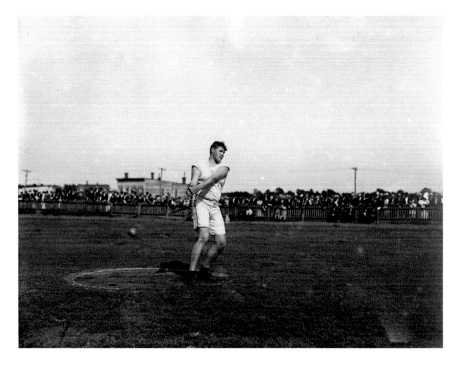

Ralph Waldo Rose. *Illustration from the "Fourth Olympiad 1908 London Official Report."*

explained tersely, "This flag dips to no earthly king," and to this day the American flag carried during the Olympic opening parade is never dipped to foreign rulers, thanks to Ralph Waldo Rose, a proud Irish-American who had been born in Kentucky.

There was some fallout from Rose's failure to dip the flag. British judges at the games rendered several controversial decisions against America's athletes, which American officials felt stemmed partly from the flag incident. The English crowds, however, displayed no antipathy toward the American athletes. The Irish-Americans on the team having made their statement, Rose once again took the gold medal in shot put but failed to medal in the tug of war. In 1909, Rose, who earlier had been the first shot putter to break fifty feet, set a world record of fifty-one feet, a record distance that lasted sixteen years. In the 1912 Stockholm Olympics, Rose took silver, losing out to fellow American Patrick McDonald in the shot put, but won gold in the two-handed shot put and placed eleventh in the discus throw and eighth in the hammer throw. In all, Rose won three gold, two silver and one bronze medal in Olympic competitions.

Consistently acclaimed by American athletic officials as "one of the greatest athletes and shot putters in the world," Rose was expected to do well again competing at the Olympic Games held in Berlin, Germany, in 1916. He was the American shot put champion for 1907, 1908, 1909 and 1910 and always trained hard and remained fit. Since the average life of a track and field athlete was much longer than that of a runner or a jumper, and since Rose was still a young man, there was no reason to think that he could not compete successfully in Berlin. However, it was not to be. Rose was stricken with malaria and died from the disease on October 16, 1913, at only twenty-nine years old. His defiant gesture while passing the royal box in England remains one of the Olympic Games' most memorable moments, and the legacy that Rose created of never dipping the American flag to a foreign ruler remains in place.

Daniel Carter Beard

1850–1941

"Remember to be a good scout, and always help the elderly across the street."
Daniel C. Beard—one of the founders of the American Boy Scouts—from
Covington, Kentucky

Daniel Carter Beard, the revered founder of the Boy Scouts of America, was raised in Covington, Kentucky, in a stately mansion overlooking the Ohio and Licking Rivers. He grew up at a time when men like Teddy Roosevelt ballyhooed high-spirited outdoor activities and rugged individualism. "Uncle Dan," as Beard was later affectionately known in scouting circles, was the son of a painter who had served as a captain in the Union army during the Civil War. Young Daniel developed his lifelong love for the outdoors playing games with his childhood friends, sliding down riverbanks and exploring the environs of the Ohio and Licking Rivers. Later, these childhood experiences, and others he experienced while playing in the outdoors, formed the basis of what Beard would term "the scouting life."

Like his father, Daniel Beard was an artist. Daniel, in fact, would become an acclaimed artist whose work appeared in several of Mark Twain's books, including *A Connecticut Yankee in King Arthur's Court*, and he also contributed articles to popular magazines of the era. His real passion, however, was to be found in his work with young boys and his love of nature. Beard's goal was to expose boys to the outdoors and to teach them to respect, use and live off the land. Accordingly, in recognition of his Kentucky heritage, Beard founded an organization called the Sons of Daniel Boone, the precursor to what later became the Boy Scouts of America.

Beard, who served as the national scout commissioner from 1910 to 1941, became a dramatic force within the scouting organization that he helped to found. He designed its patches, uniforms and awards. He also created the hand sign currently used by Cub Scouts and helped his sister to become one of the founders of the Boy Scouts' sister organization, the Camp Fire Girls.

Rascals, Heroes and Just Plain Uncommon Folk

Beard's seminal work, *The American Boy's Handy Book*, published in 1882, became a standard guidebook for both the Sons of Daniel Boone and the Boy Scouts of America. Beard died in 1941, at age ninety-one, in New York, where he is buried. In his hometown of Covington, he is remembered by a plaza named for him located next to his boyhood home and by a bridge across the Ohio River that bears his name. Uncle Dan would have been proud of both.

Elijah McCoy

1842/43–1929

"Yes indeed, it's the real McCoy!"
Elijah McCoy—son of runaway slaves from Paris, Kentucky

Elijah McCoy, an African American inventor who became famous for developing and marketing a popular line of industrial lubricants, was the son of runaway slaves from Kentucky. His parents, George and Emillia McCoy, escaped from servitude on a farm in central Kentucky and crossed the Ohio River into Indiana in 1837 and then were led along the Underground Railroad to freedom in Canada. George McCoy joined the Canadian army, and for his service in the 1837 Rebel War he was given the title to a 160-acre Canadian homestead where he farmed and raised his family.

Elijah McCoy was born in Ontario, Canada, on May 2, 1843 or 1844, depending on which birth record is consulted. He was a precocious youth who, his parents soon noticed, had high mechanical aptitude when working on farm machinery. Elijah's parents saved their money and in 1860 sent their son to Edinburgh, Scotland, to study mechanical engineering. Still a teenager, Elijah began his engineering studies at a time when the Industrial Revolution was growing by leaps and bounds throughout the world's industrialized nations. A textbook he was using introduced McCoy to the thermodynamics of mechanical engines, knowledge that he would later use in developing his McCoy industrial lubricants for steam engines.

In 1865, after completing his studies, McCoy returned to his family's farm, where he worked a year to help repay his parents for financing his education. One year later, he moved to Ypsilanti, Michigan, where he took a job with the Michigan Central Railroad. At this time, however, the rail company employed no African American engineers, so McCoy became a fireman and oilman. His job was to stoke the boiler and lubricate the stem cylinder and sliding parts of the train. While performing these duties, McCoy noticed that hot high-pressured steam was corroding the metal parts

of the machinery he was lubricating and concluded that they needed a better lubrication, which he then formulated. Within ten years, steam engines and trains in mines and factories throughout the industrial nations of the world were utilizing McCoy Lubricants, marketed by his company's salesmen as "the real McCoy." It was a phrase that later broadened into the vernacular to mean that something was "the real thing."

In 1872, McCoy patented his first invention, a self-regulating device that utilized steam pressure in the cylinders to operate the valves. In total, Elijah McCoy registered more than fifty patents for inventions, most for improvements to steam engines. Two inventions, however—a folding ironing board and a self-propelled lawn sprinkler—were exceptions. McCoy lived in an integrated neighborhood of Detroit with his family and operated the McCoy Manufacturing Company of that city from 1920 to 1928. He retired in 1928 after failing to recover from injuries he had earlier suffered in an automobile accident. He died in 1929. Sadly, he was by then penniless, having depleted his wealth trying to perfect his various inventions. Few people have lived a more compelling life than Elijah McCoy, a son of runaway slaves, who rose up from humble beginnings to become one of the most important inventors of the early twentieth century.

Garrett A. Morgan

1877–1963

"Yes, officer, I know I ran the traffic signal; I ought to know, I invented it!"
Garrett A. Morgan—African American inventor—from Paris, Kentucky

G arrett Augustus Morgan, who grew up on his family's farm near Paris, Kentucky, would develop a range of creative talents that transformed him from a farm laborer into one of America's foremost inventors. Garrett was the seventh of eleven children born to former slaves, Sydney Morgan and Elizabeth Reed Morgan. Up until age fourteen, Garrett worked on the farm with his brothers and sisters, but in 1891 he moved to Cincinnati, Ohio, to work as a handyman for a rich landowner. Only able to complete a portion of his elementary education before moving to Cincinnati, Morgan resolved to continue his studies, saved enough money to hire a private tutor and subsequently studied English grammar.

Morgan moved to Cleveland, Ohio, in 1895. There he took a job as a sewing machine repairman for a clothing manufacturer and soon earned a fast-spreading reputation for being a multitalented tinker and someone capable of fixing all things mechanical. Eschewing several job offers from various manufacturing firms in the Cleveland area, Morgan opened his own sewing equipment and repair shop in that city in 1907. He eventually had thirty-two employees in this firm and used its success to finance several other business enterprises in Cleveland. The products his sewing shop produced—coats, suits and dresses—were all fabricated by equipment that Morgan had made.

Morgan next entered into the newspaper business in Cleveland, establishing in 1920 the *Cleveland Call* (later renamed the *Call and Post*), a newspaper catering to the news and issues in that city's African American community. Even though he was a well-known and successful businessman, along with many of his associates and peers in Cleveland's African American community, he had to deal continually with the racial biases and de facto segregation of his times.

Rascals, Heroes and Just Plain Uncommon Folk

One of the first examples of this problem centered on a device Morgan invented in 1914, which he called the Morgan Safety Hood and Smoke Protector. Morgan had invented the device, which was later refined by the U.S. Army for use as a gas mask during World War I, to allow firemen to enter a smoke-filled structure and breathe clean air. Morgan also planned to market his invention as a piece of equipment that might allow anyone working in dust or noxious fumes to don the device and breathe freely. For two years, Morgan demonstrated his invention at a number of equipment expositions held across America but there was little interest since it had not been tested in life-threatening conditions.

Then in 1916, the event Morgan had been waiting for, the opportunity to test his device during a real-life disaster, happened. On July 24, a tunnel being dug by the Cleveland Water Works beneath Lake Erie exploded, trapping thirty-two workers beneath. The tunnel quickly filled with dust, smoke and noxious fumes and it seemed everyone below was doomed to die. Someone at the scene, however, knew about Morgan's safety hood and smoke protector and ran to the inventor's home, where Morgan was relaxing with his brother, Frank. The two brothers immediately rushed to the disaster scene, put on safety hoods and entered the tunnel. After several tension-packed minutes, Garrett emerged from the tunnel carrying a survivor on his back, as did his brother seconds later, and the crowd erupted with thunderous applause and cheers. Several more men were saved but not all. Nonetheless, word of the rescue soon spread nationwide and to England as well, and Morgan's company was bombarded with orders from fire and police departments for the device. But the prevailing ugly face of racism soon put an end to it all, and most of these orders were cancelled when it was discovered that the device's inventor was a black man.

Undaunted, Morgan continued to invent. Over the course of his life he created and patented a variety of inventions ranging from a sewing machine lubricant that straightened kinky hair to a number of industrial lubricants and mechanical devices. His most noteworthy invention was the traffic device, an idea he came up with after witnessing an accident between a horse-drawn cart and an automobile in which the driver of the car was knocked unconscious and the horse had to be destroyed.

The dawn of the automobile age in an urban setting was a blending of chaos and confusion as animal-powered conveyances, bicycles and gasoline-powered automobiles maneuvered willy-nilly through the streets of American cities. Cleveland was no exception. Morgan concluded that what was needed in cities was a piece of equipment that directed traffic automatically, ending the need for workers or policemen to stand on corners to do so. The device

he created, the Morgan Traffic Signal, was a T-shaped pole unit featuring hand-cranked positions: stop, go and an all-directions stop. The third position, which halted all traffic, allowed pedestrians to cross streets more safely. Morgan sold his invention to the General Electric Corporation for $40,000 and his invention was the forerunner of the modern three-colored traffic light that now governs traffic flow.

As one of Cleveland's most successful African American businessmen, Morgan usually was cast into the limelight any time matters of civil rights were at issue in his city. By nature he was quiet and unassuming, but he did believe in fighting on behalf of racial equality, and he devoted both time and money to achieving fair treatment for African Americans. He was treasurer of the Cleveland Association of Colored Men and remained actively involved in that organization from 1914 until it merged with the National Association for the Advancement of Colored People. Following the merger, he joined and remained an active member of the NAACP until his death in 1963.

It was said that Morgan "had walked with giants," for he numbered among his business acquaintances and friends the likes of financier J.P. Morgan (after whom Garrett Morgan named one of his sons) and business tycoon John D. Rockefeller. Morgan was honored both while he was alive and after his death for his many inventions and achievements. His inventions earned him several accolades and achievement medals throughout his life. His list of posthumous recognitions include Prince George's County's Garrett A. Morgan Boulevard, in Maryland; the Washington, D.C. Metro system's Morgan Boulevard Station; the Garrett Morgan (Water) Treatment Plant in Cleveland; and the Garrett A. Morgan Cleveland School of Science. Garrett Morgan is thus appropriately honored and memorialized for having had a lifetime filled with significant achievements.

John T. Thompson

1860–1940

"You might want to consider trading in that revolver of yours for the machine gun I just invented."
John T. Thompson—army ordnance expert—from Fort Thomas, Kentucky

John Taliaferro Thompson was the inventor of the automatic weapon known as the Thompson machine gun (Tommy gun), an invention that during the American gangster era of the 1920s and 1930s became the weapon of choice and symbol of violence for criminals and lawmen alike. Such notorious outlaws as John Dillinger, Bonnie and Clyde and Pretty Boy Floyd, along with the seven victims of the St. Valentine's Day Massacre, were all, along with many unnamed criminals, gunned down by Tommy guns. Lawmen and innocent bystanders, most of their names now long forgotten, fared no better. Thompson's Tommy gun changed the game, so to speak, and its invention previewed the devastating firepower of modern-day automatic weapons.

John Thompson came from a military family. His father, James, graduated from West Point in 1851 and ended his military career with the rank of lieutenant colonel. John grew up at military installations around the United States as his father pursued his career. In 1878, John T. Thompson was awarded an appointment to West Point; he graduated in 1882, eleventh in his class. John soon became recognized for his expertise in ordnance and logistics, but despite a very promising future as an army officer, he resigned his commission in 1914 to go to work for the Remington Arms Company. When America entered World War I in 1917, Thompson was recalled to active duty as director of arsenals with the rank of brigadier general.

His next move was bold. Thompson believed that the rifles American troops had been issued to fight with were outdated and new weapons were needed. The switchover, however, would mean that production of the older guns would be halted for a few months. Thompson immediately ordered

John T. Thompson. *Courtesy of the U.S. Army.*

the switchover, a gutsy move that worked. Thompson not only introduced an improved rifle, a new Springfield, but under his tutelage production of the improved rifles soon increased dramatically, and the production gap was filled.

Rascals, Heroes and Just Plain Uncommon Folk

After World War I ended in 1918, Thompson left the army and founded his own company, the Auto-Ordnance Corporation. That same year, he introduced his new invention, the Thompson submachine gun, which revolutionized modern weapons and was soon nicknamed for him. Thompson enjoyed considerable success and fame and made lots of money from this invention. However, one incident involving his company caused him considerable anguish. In the early 1920s, his son, Marcellus Thompson, also a West Point graduate, while serving as vice-president at the Auto-Ordnance Company, was accused of sending a shipment of five hundred Thompson machine guns to terrorists in Ireland. As it turned out, the culprit was another company vice-president who had been a longtime supporter of Irish independence. Thompson was relieved that his son had not been involved but was always troubled that an official of his company had been implicated.

Thompson, whose son Marcellus preceded him in death by one year, died in 1940. John T. Thompson, the man from Kentucky who did so much to change the story of military weapons, was eulogized for having done so when he was buried with full military honors on the grounds of the U.S. Military Academy at West Point in New York.

Floyd Collins

1887–1925

"I'm trapped here in a lonely sandstone cave."
Floyd Collins—prominent western Kentucky cave explorer—from Flint Ridge in
Edmonson County, Kentucky

Charles Lindbergh's transatlantic flight and his son's kidnapping and murder, along with two other news stories, the death of Floyd Collins and the Scopes Monkey Trial, are said to have constituted America's four most sensational media events of the 1920s. Two of these stories, the death of cave explorer Floyd Collins and the Scopes Monkey Trial (discussed next), involved Kentuckians.

Floyd Collins lived in western Kentucky's cave region his entire life. He began exploring the extensive cave system in this region as a young man, and in 1925, the year of his tragic death, Collins was considered the foremost authority on the caves and cave systems of western Kentucky. In fact, some have gone so far as to label Collins "the greatest cave explorer ever known." In 1917, Collins discovered Crystal Cave, which was located at the edge of the vast Mammoth Cave system, a discovery the Collins family tried to turn into a commercial enterprise. However, attendance at Crystal Cave was disappointingly low. In the hope that he might be able to uncover a new entrance to the area's cave systems and thereby generate a new spark of interest in Crystal Cave, Floyd entered a nearby sandstone cave on January 30, 1925. While crawling through a narrow crawlway that ran fifty-five feet below the surface, Collins became trapped and would remain so for thirteen highly melodramatic days until he died from starvation and exposure.

Collins had become trapped in what the news media later dubbed "Sand Cave" after accidentally knocking over his lamp while exiting the cave. Crawling in darkness, he dislodged a 26½-pound rock from the ceiling, which pinned his leg in a manner that made it impossible for Collins (and later his rescuers) to remove the rock. The next day friends discovered Collins

trapped only 150 feet from the cave's entrance. They took him hot food and ran an electric light down the passage to provide him light and warmth. This passage, however, collapsed on February 4, leaving rescue teams with twin options—cutting a shaft from above or digging a lateral tunnel that would intersect from above.

A reporter from the *Louisville Courier-Journal*, William Burke "Skeets" Miller, spent several hours talking to Collins, and his dramatic reports of these conversations would gain Miller a Pulitzer Prize. Miller's reports, along with regular news bulletins, were picked up by newspapers and radio stations nationwide. The event soon turned into a carnival as food and souvenir vendors set up shop and tens of thousands of people gathered outside the cave waiting to hear news of Floyd's fate. After the collapse in the cave, which cut off communications to the outside, Collins lay alone and forsaken, his fate in the hands of his rescuers.

They reached him on February 17, thirteen days after he was trapped, but Floyd was dead. Realizing that it was too dangerous to remove the dead man, the rescuers left his body and hastily filled the shaft with debris. Two months later, relatives reopened the shaft, dug a new tunnel and removed the body. The family placed it in a glass-topped coffin in Crystal Cave, where it was on public display until 1961, when Crystal Cave was purchased by the National Park Service. In 1989, Floyd Collins was reinterred in a cemetery nearby.

Floyd Collins's ordeal and death spawned several tributes, including two popular songs released in 1925, "The Death of Floyd Collins" and "The Floyd Collins Waltz." His life and death also inspired a musical, a documentary film, several books, a museum and a number of other tributes. In 1951, Billy Wilder paid tribute to Collins in *Ace in the Hole*, a film that focused upon the media circus surrounding Floyd's death. Black Stone Cherry, a band based in Kentucky, included a song entitled "The Ghost of Floyd Collins" on an album it released in 2008. Perhaps the strangest twist to the story of Floyd Collins took place on the night of March 18–19, 1929, when his body was stolen from Crystal Cave. The body was soon recovered but his left leg, the one that had been pinned by the rock in the cave, was missing and was never recovered.

John Scopes

1900–1970

"Maybe, my 'monkeying around' with evolution wasn't such a good idea after all."
John Scopes—high school general science teacher and football coach in Dayton,
Tennessee—from Paducah, Kentucky

The so-called "Scopes Monkey Trial" held in Dayton, Tennessee, in 1925 helped to establish the still hotly debated battle lines between evolutionists and creationists concerning the origins of mankind. The trial showcased eloquent arguments by the defender of creationism, the famed golden-tongued orator William Jennings Bryan, pitted against fellow attorney Clarence Darrow, a skeptic and an able defender of evolution. The outcome of the trial was never in doubt. All parties involved understood that the defendant, Kentuckian John Scopes, would be found guilty—they also understood that the trial constituted a test case that placed the issue up for debate and that whatever punishment Scopes received would essentially be irrelevant. Scopes was found guilty after only nine minutes of jury debate, was fined $100 and then had to fend off a parade of benefactors offering to pay his fine.

John Scopes, who was born in Paducah, Kentucky, arrived in Dayton, Tennessee, in 1924, after completing a law degree at the University of Kentucky in Lexington. He was hired by the high school in Dayton as a football coach and a substitute general science teacher. A fit and lean bachelor in his mid-twenties, with a full head of red hair, Scopes regularly attended the Presbyterian church while living in Dayton, an activity he later admitted was more in search of dates than in search of religion. One day in late May 1925, while playing tennis, Scopes was summoned to a meeting at "Doc" Robinson's drugstore located in downtown Dayton. Asked by one member of a group of men gathered there if he had ever assigned his students readings from the chapter on evolution in George W. Hunter's *Civic Biology*, Scopes replied that he had. Although at first reluctant, Scopes was persuaded by the men gathered that day to test the Tennessee state law

John Scopes. *Courtesy of Special Collections & Archives, University of Kentucky.*

that prohibited the teaching of evolution in state schools by teaching from Hunter's chapter on evolution the following day. Ironically, Scopes was ill the following day and never completed his task. It did not matter. The word was out about the plan to test the state's law and Scopes was charged with a crime and ordered to stand trial. The stage was thus set for the ensuing high drama of the Scopes Monkey Trial.

The entire prosecution case at the trial lasted a mere two hours. Scopes, who showed up in court wearing a blue shirt and a hand-painted bow tie, was calm and collected throughout his entire testimony on the witness stand. When asked by the prosecutor if he had "been teaching 'em" from Hunter's book, Scopes answered, "Yes." Scopes then added that while he was substituting for the regular biology teacher in April 1925, he had assigned his students Hunter's chapter on evolution to read but that no discussion of the chapter had been conducted afterward. Scopes did recall that he had taught the topic that month in a general way to his general science students. The rest of the trial involved Bryan and Darrow arguing on behalf of their respective beliefs.

Darrow concluded his defense of Scopes by asking the jury to return a verdict of guilty in order that the verdict might be appealed to a higher court. Once the guilty verdict had been rendered, the trial judge, Judge Ralston, asked Scopes to stand before him. After pronouncing sentence and fixing Scopes's fine, Judge Ralston asked the defendant if he had anything to add, to which Scopes responded that he thought he had been convicted of violating an unjust statute and that the fine was unjust.

Scopes's notoriety from the trial landed him a free graduate education at Stanford University and lasting fame at the center of the controversy concerning the origins of mankind. He soon sought to eschew the notoriety, proclaiming that although he would accept the offer for a free graduate education, he did not wish to profit "one penny" more from his role in the affair. After completing his graduate degree, Scopes had a successful career working as a commercial geologist. The story of the events that took place in Dayton, Tennessee, was later chronicled in the bestselling book *Inherit the Wind*, which was made into a movie in 1960. As time passed, many residents of Dayton came to regard what had transpired in 1925 as an incident that had "put their town on the map" rather than as a defining moment between the theories of creationism and evolution. As for Scopes, he preferred to put it all behind him, and toward the end of his life he proclaimed philosophically, "A man's fate is often stranger than anything the imagination can produce." Scopes could have also added that fate had cast him into a position that helped turn a page of history, thereby assuring that his name would forever be tied to a trial that was to remain a significant historical event.

Alben Barkley

1877–1956

*"Never act as a judge at a beauty or baby contest. You may have designs on the beauty
that will get you in trouble or the unsuccessful babies you voted against might grow up
before you leave office and return the favor."*
*Alben W. Barkley—United States senator and vice president—from near Lowes in
Graves County, Kentucky*

The witty remarks paraphrased above, ingredients commonplace in the
speeches he would deliver, helped to make Alben William Barkley, the
son of John and Eliza Smith Barkley, one of the most colorful and best-known
political orators in America during the twentieth century. Alben Barkley
worked on the family farm until enrolling at Marvin College in Clinton,
Kentucky. Barkley, who was poor, took a full-time janitorial job to pay for his
education. It therefore took him five years to graduate college, after which
he undertook additional studies at Emory College in Atlanta, Georgia, and
then at the University of Virginia Law School in Charlottesville.

Barkley was admitted to the bar in 1901. By then, he was living in Paducah,
in McCracken County, Kentucky, where he belonged to the local Episcopal
church as well as a number of local civic organizations. Barkley was a talented
speaker with a rich baritone voice who spliced together homespun humor and
interesting stories, soon becoming a public speaker in high demand. Barkley
entered politics as a Democrat and was elected prosecuting attorney in
McCracken County in 1905, a post he held until 1909. His style of politicking
included relentless campaigning, vigorous hand shaking and polished debating.
From 1909 until 1913, Barkley served as judge of McCracken County Court.

Barkley, who was not afraid to "get down and dirty" when engaging
his political opponents in debate, earned a reputation early on as the
champion of the little man, especially the poor rural farmers of his home
district. This important bloc of voters helped Barkley win election to
the U.S. House of Representatives in 1913, a seat he retained for seven

Alben Barkley. *Courtesy of Special Collections & Archives, University of Kentucky.*

consecutive terms between 1913 and 1927. In Congress, Barkley's record was that of a progressive. He favored government regulation on a number of social issues, including regulating child labor in interstate commerce and passing legislation to ban liquor sales in the District of Columbia. Barkley delivered hundreds of talks on behalf of fellow Democrats seeking election or reelection to Congress in these years, thereby establishing his reputation within the Democratic Party as well as making a number of important political friends and allies.

Rascals, Heroes and Just Plain Uncommon Folk

Barkley resigned his seat in the House in 1926 to run successfully for the Senate. After his election, Barkley received a number of Senate committee appointments not normally assigned to a junior senator, marking him as a rising star within the Democratic Party. After being mentioned as a vice presidential candidate in 1928, Barkley was chosen in 1932 to deliver the keynote address at the Democratic National Convention that nominated Franklin D. Roosevelt to run for president. In a rousing speech, Barkley helped rally delegates behind the party platform of reform and identified himself as one of his party's foremost spokesmen. After Roosevelt was elected, Barkley, who would be reelected to the Senate in 1932, 1938 and again in 1944, became one of the most reliable and able supporters of the New Deal policies advanced during Roosevelt's terms in office.

Barkley, who had been nicknamed the "Iron Man" because of the number of speeches he would deliver each day during a campaign, had an extremely interesting political showdown in the 1938 Senate race. He was opposed in the Democratic primary by A.B. "Happy" Chandler, the governor of Kentucky, another stump speaker with considerable political talents. During the campaign, Barkley was joined by President Roosevelt for a number of train "whistle stops" in Kentucky. At one of these, held at the Old Latonia Racecourse in Covington, Chandler, who was uninvited, joined Barkley and Roosevelt on the train's rear platform as they were speaking to a large crowd. Roosevelt knew how to handle the problem. He shook hands with Chandler and then told the crowd that their current governor was doing such a good job that they should retain him as governor because with Barkley they already had a good senator who was also doing a good job.

Roosevelt had good reason to want to keep Barkley in Washington. With FDR's support, Barkley had been elected Senate majority leader in 1937, a position he retained until 1947, after which he served as Senate minority leader from 1947 until 1949. Throughout Barkley's term of leadership in the Senate, Roosevelt counted on him to garner Senate support for the president's policies. In 1944, however, Barkley broke with FDR on tax issues. The president had vetoed a tax bill because the rates were too low and Barkley, always the common man's champion, resigned his leadership post in the Senate in protest and called for a veto override. The veto was overridden, Barkley was reelected to his leadership post and FDR was shown that Barkley, not the president, was in control of the Senate.

During the 1944 Democratic Convention, Barkley was snubbed as candidate for vice president in favor of Missouri senator Harry S. Truman. Nonetheless, Barkley stayed true to his party and its principles and gave his unwavering support to the Roosevelt/Truman national Democratic ticket.

Afterward, Barkley continued to lead the Senate and was instrumental in ensuring the Senate's passage of the bill that created the United Nations.

In 1948, Barkley was once again chosen as keynote speaker at the Democratic National Convention, and this time Harry Truman, who had become president after FDR died in office in 1945, chose Barkley as his running mate. It was a pairing of two men with great political skills and relentless energies that were combined on the campaign trails in 1948 to gain an upset victory. Alben Barkley was sworn in as the nation's thirty-fifth vice president on January 20, 1949, at age sixty-one, the oldest man ever to hold the office. He would serve faithfully in that office until 1952. He was the fourth Kentuckian, along with Richard Johnson, John C. Breckinridge and Adlai Stevenson, to hold that office. Nicknamed "The Veep" by his grandson, Barkley also would become the only vice president to get married while serving in office.

Barkley's advanced age in 1952 prevented him from seeking the presidency. He retired for a time, hosted a television show and then concentrated on writing his memoirs. But the old political bug bit him again in 1954, and he once again was elected to the Senate, handily defeating Republican incumbent John Sherman Cooper. Barkley's Senate colleagues, acknowledging his prominence, appointed him to the prestigious Foreign Relations Committee. On April 30, 1956, Barkley traveled to Lexington, Virginia, to deliver the keynote address at a mock political convention being held by students at Washington and Lee University. At the end of his speech, Barkley proclaimed, "I would rather be a servant in the House of the Lord than to sit in the seats of the mighty." He then turned to leave the stage, suffered a massive heart attack and died, having just delivered one of the most memorable exit lines of all time.

A.B. "Happy" Chandler

1898–1991

"Gentlemen, the reason Mr. Robinson will be playing baseball for the Brooklyn Dodgers this year is because it is the right thing to do."
A.B. "Happy" Chandler—politician and baseball executive—from Corydon, Kentucky

Former Kentucky governor and baseball commissioner A.B. "Happy" Chandler, rather than Brooklyn Dodger baseball executive Branch Richey, was the man most responsible for the integration of Major League baseball. Chandler's astonishing political acumen, coupled with an uncanny knack for recalling names, won him election in 1935 as Kentucky's youngest governor ever and subsequently, in October 1939, an appointment to the U.S. Senate and then election to a second term.

Chandler relished the spotlight of high-profile opportunities, and when asked to succeed Kennesaw Mountain Landis as the Major League baseball commissioner in 1947, he jumped at the chance. However, Chandler's independent spirit and the innate archaic conservatism of the baseball owners soon erupted into a series of spirited conflicts and disputes between Chandler and his new bosses. Chandler, who had grown up on a farm in rural western Kentucky, fancied himself a man of the people while the baseball owners, a group of wealthy and privileged men, were used to having their own way on matters.

The rub came when it became clear that Chandler intended to do things his own way whether the owners liked it or not. Adding to the drama was the fact that Harry S. Truman, a hard-drinking, straight-talking, no-nonsense protégé of machine politics in Missouri, had become president in 1945 upon Franklin Roosevelt's death. Truman, too, believed that he should govern as a man of all, not just some, of the people, and by 1947 was said to be considering integrating the U.S. armed services, which he later ordered in 1948.

Enter Jackie Robinson, a Negro army officer who just happened to be rare baseball talent. After his discharge from military service in 1945, Robinson

A.B. "Happy" Chandler. *Courtesy of Special Collections & Archives, University of Kentucky.*

was signed to play shortstop for the Kansas City Monarchs in the Negro Baseball League. And then came the moment of truth for both future Baseball Hall of Famers Jackie Robinson, a talented multi-sport athlete at UCLA, and Happy Chandler, the border state politician. Taking his cue from Truman, Chandler sanctioned the integration of baseball by allowing the addition of Robinson to the roster of the Brooklyn Dodgers and then awaited developments. Along the way, Chandler had decided to give a fellow Kentuckian, "Pee Wee" Reese, the Dodgers' regular shortstop, the assignment of seeing to it that Robinson had a fair chance to succeed as a player.

The rest is history. Robinson went on to achieve legendary status in baseball and Reese, along with Chandler and Robinson, would later be inducted into the Baseball Hall of Fame. A defining moment in modern-day sport had taken place, and the man directly responsible for this was A.B. "Happy" Chandler, a Kentuckian. Chandler, who died in 1991, served as Kentucky's governor for a second term from 1955 to 1959 and remains one of the most memorable public figures ever to serve the Commonwealth of Kentucky and the nation.

Eddie Arcaro

1916–1997

"It's real simple, when I ride, I ride to win."
Eddie Arcaro—champion American jockey—from Newport, Kentucky

George Edward "Eddie" Arcaro was one of the most colorful and successful American jockeys of all time. When competing in a race, he asked for and gave no quarter, a survival technique he developed while riding during the rough and tumble era of the 1930s. In those days, horse racing rules were lax and jockeys rode at their own peril. Arcaro not only survived but was soon setting new standards for riders. He won his first Kentucky Derby in 1938 aboard Larwin and eventually four more, establishing the current Derby record of five riding victories, which he shares with jockey Bill Hartack. Arcaro also holds the record for the most Triple Crown riding victories (seventeen) which includes his Derbies, six victories in the Preakness Stakes and six wins in the Belmont Stakes. "Fast Eddie," as Arcaro was sometimes called, was fearless and often fiery. In 1942, in an incident in which Arcaro knocked jockey Vincent Nordase over the racetrack's inside rail, Arcaro was called before the stewards to explain what had happened. He could have gotten off with a light suspension, since Nordase had committed the first foul. But instead of apologizing, Arcaro responded, "What I really meant to do was kill that Cuban SOB." Arcaro was suspended from riding for a year at the peak of his career.

Arcaro was raised in both Newport and Covington, Kentucky, as his father, an Italian immigrant, frequently changed jobs. Eventually, his family owned a bar in Erlanger, Kentucky. While the slender five-foot, three-inch Arcaro was caddying golf at Highland Country Club in Fort Thomas, Kentucky, a horseman suggested that he should try to become a jockey. Dropping out of school at age thirteen, Eddie began galloping horses at the original Latonia Racecourse in Covington, earning twenty dollars a month and receiving little encouragement from trainers. At age fifteen he rode his first race, illegally,

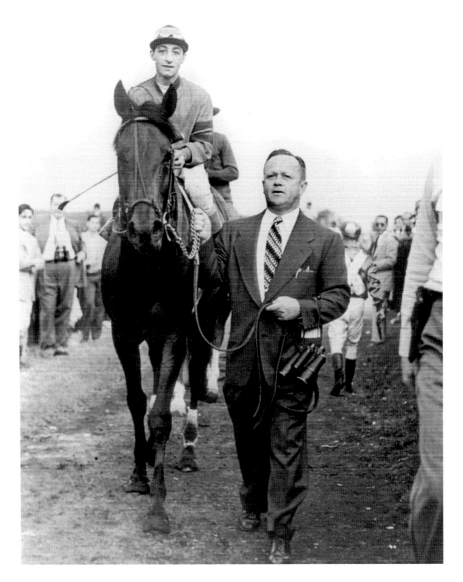

Eddie Arcaro. *Courtesy of the author.*

at Bainbridge Park near Cleveland, Ohio, and rode in a few other races at Latonia. Then he stowed away on a freight train headed to Agua Caliente Racecourse in Tijuana, Mexico, where there were few rules and a rider's age did not matter.

Arcaro lost 45 races before riding his first winner, a claiming-level (lower-level) horse named Eagle Bird, at Agua Caliente on January 14, 1932.

Rascals, Heroes and Just Plain Uncommon Folk

Now sixteen years old and finally able to ride legally, Eddie returned to the United States and quickly became the top apprentice at the Fair Grounds Racecourse in New Orleans. He moved to Chicago, where he was signed to his first riding contract by Warren Wright, owner of the powerful Calumet Farm racing stable. A contract rider for either Calumet or Greentree Stables throughout his career, Arcaro compiled an astounding riding record. In his thirty-year career, from 1931 until his retirement in November 1961, Arcaro had 24,092 mounts and won 4,779 races at a winning clip of 19.8 percent. In addition to his 17 Triple Crown victories, he won 10 Jockey Club Gold Cups, 4 Metropolitan Handicaps and 8 Suburban Handicaps.

The only two-time winner of American horse racing's Triple Crown, first on Whirlaway in 1941 and then aboard Citation in 1948, Arcaro was the nation's leading money winner six times, received the prestigious George Woolf Memorial Jockey Award in 1953 and retired with what was, at the time, record purse earnings of $30,039,543. He was inducted into the Racing Hall of Fame in 1958.

There are many stories related to Arcaro's riding career that reflect a set of standards of times gone by in horse racing. On one occasion, Arcaro was sitting in the jockeys' room at a racetrack in the Chicago area when a stranger approached and asked Eddie what he thought about his mount's chances in the last race. Eddie told the stranger he would win, which he did. Afterward, the stranger handed Eddie $500. This happened four more times, but when Eddie discovered that the stranger was Al Capone, he decided to stop giving out information. After his retirement, Arcaro frequently served as a race expert and commentator on television. He retired to Miami, Florida, and played golf daily, sometimes joining a foursome that included baseball great Joe DiMaggio. Arcaro, who died in 1997 of liver cancer, is still heralded as one of thoroughbred racing's all-time greats—he certainly was one of the most colorful characters in that sport.

Bill Monroe

1913–1996

"When that fiddle's playing and the band is sounding good, bluegrass music can touch your heart."
Bill Monroe—bluegrass musician—from Rosine, Kentucky

William Smith Monroe grew up in Rosine, Kentucky, the youngest of eight children born to James "Buck" and Malissa Monroe. Bill experienced hard times growing up on the family farm in Kentucky. His mother died when Bill was ten and his father, who died six years later, had to travel to make a living. Bill was essentially raised by the older children and by his mother's brother, Pendleton Vandiver ("Uncle Pen"), a talented fiddle player. In fact, the entire Monroe family was talented musically. Bill's mother played the harmonica and guitar and his father was a capable step dancer. Bill's sisters danced and sang, and his brothers danced and played instruments. This proved to be a problem for Monroe, who wanted to play guitar but who, as the youngest child, had to learn to play the instrument his brothers disliked and shunned, the mandolin.

The hard times that the Monroe family encountered caused Bill's siblings to leave home and to take work in factories near Chicago, Illinois. Bill's musical talents were developed with his Uncle Pen when they performed together at dances throughout the western Kentucky region. Bill, who, like his brothers, was a good baseball player, was recruited to join them working and playing baseball at a factory near Gary, Indiana. Soon Bill and his brothers, Birch and Charlie, were singing and dancing with their girlfriends on a barn dance show broadcast live over Chicago radio station WLS. Encouraged to strike out on their own, Charlie and Bill Monroe traveled to the Carolinas in 1936, where from 1936 to 1938 they became one of the top country and gospel singing duos in the region. The brothers, however, did not get along with each other, so in 1938 Bill left and struck out on a career of his own.

Rascals, Heroes and Just Plain Uncommon Folk

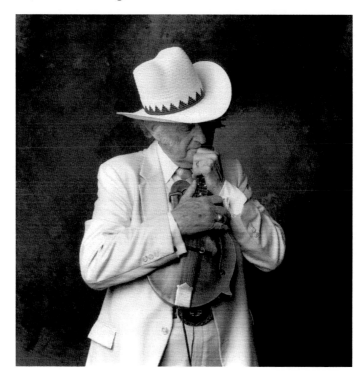

Bill Monroe.
Courtesy of the author.

After brief stays in Arkansas and Georgia, Bill took a job at a radio station in Asheville, North Carolina, and, while performing there, formed his first band, which he named the Blue Grass Boys. In 1939, Monroe and his band were hired as regulars on the Grand Ole Opry in Nashville, Tennessee, and from the Opry's stage, where he performed for fifty years, Bill Monroe, the "Father of Bluegrass Music," defined and spread what came to be known as bluegrass music. In 1946, Monroe added Earl Scruggs, a three-finger-style banjo prodigy, and talented guitarist Lester Flatt to his band, thereby completing the composition of what many regarded as the greatest bluegrass band ever assembled. Monroe and this band recorded sixty songs over the next two years, many of which are still bluegrass classics.

Monroe also published a songbook in 1946 entitled *Country Music Bluegrass*, which some regard as the event that led others to begin referring to the music that Monroe and his band were playing as bluegrass music. Sometimes referred to as "folk music in overdrive," bluegrass music, which uses tempos much faster than country music, is acoustical music played generally by an ensemble consisting of four, five or six musicians. The standard stringed instruments in a bluegrass band are mandolin, fiddle, upright bass, banjo and one or two guitars, one of which is sometimes the Dobro. The lead

singer, most often a tenor, usually sings the verses and members of the band join in to harmonize on the chorus.

Monroe was a perfectionist who considered any deviations from bluegrass music as he had defined it somewhat akin to high treason. Flatt and Scruggs left Monroe in 1948 to become bluegrass stars in their own right, as later did a parade of other talented musicians; in all, over 250 musicians performed with Bill Monroe and his band. The changing musical tastes of the 1950s and 1960s almost made bluegrass music seem passé, but Monroe stuck with it, and during the 1970s and 1980s bluegrass music made a comeback, partly because it allowed musicians to showcase their instrumental talents when performing breakaway solos on stringed instruments.

Monroe continued to tour and play music on the Opry's stage until his death in 1996. By then, he was a music legend, and bluegrass music had spread out from its base among the peoples of Appalachia and was reaching a worldwide audience. Monroe was cantankerous to the end, smarting every time an innovation came to bluegrass music. Today, bluegrass music is played nationwide and worldwide; over eight hundred radio stations in America include bluegrass in their regular programming, as do over fifty stations in Europe. In Japan alone, there are more than five hundred bluegrass bands. Bill Monroe, the father of bluegrass music, created a new blend of music totally American in its origins, the only such musical category that can be so characterized.

Husband Kimmel

1882–1968

"Admiral Kimmel, we are under attack!"
Admiral Husband Kimmel—commanding officer in charge of American Naval Forces at
Pearl Harbor in Hawaii on December 7, 1941—from Henderson, Kentucky

Naval commander Husband E. Kimmel, the son of Marius and Sibbella Lambert Kimmel, was born in 1882 in Henderson, Kentucky. After graduating high school in Henderson, Kimmel attended Central University in Richmond, Kentucky, after which, in 1900, he received an appointment to the United States Naval Academy at Annapolis, Maryland. He graduated there in 1904, thirteen in a class of sixty-one, and in 1906, after completing his required sea duty, Kimmel was commissioned an ensign. A gunnery and ordnance specialist, he spent his early military postings on battleships. During World War I, he served with a battle group attached to the British Royal Navy.

Kimmel was promoted to captain in 1926 after having served as an executive officer on an American battleship, commanding two destroyers and completing a series of command courses at the U.S. Naval War College. He was promoted to rear admiral in 1937 and in February 1941 was named to command America's Pacific fleet. Kimmel's focus, at this time, was to prepare the Pacific fleet for war through a series of demanding exercises and to bolster the defenses of Midway and Wake Islands. Kimmel, who had been assigned the temporary rank of admiral, was later credited as having placed the American Pacific fleet that remained after the Japanese attack on Pearl Harbor in a far better condition to fight than before he had taken command.

The details of the Japanese attack on Pearl Harbor on Sunday morning, December 7, 1941, are well known. They have been played and replayed myriad times in books, newspaper and magazine articles, movies and television docudramas. The sight of the unprepared American military forces being

pummeled by Japanese aircraft has been ingrained in memory. Also familiar is the sight of General Walter Short, the army's supreme commander in Hawaii, and Admiral Husband Kimmel, his naval counterpart, watching either helplessly or aghast as the tragedy at Pearl Harbor unfolded. It was reported by a fellow naval officer that "Kimmel stood by the window of his office at the submarine base during the attack, his jaw set in stony anguish." As he watched the disaster unfold across the harbor, a spent .50-caliber bullet from a machine gun brushed Kimmel's white jacket, bruised his chest and landed on the floor, after which Kimmel reportedly exclaimed, "It would have been merciful if it had killed me."

Another navy man present wrote that during the attack, Admiral Kimmel tore off his four-star epaulets and replaced them with the two epaulets worn by a rear admiral, apparently realizing that he would soon be relieved of his command and returned to his permanent two-star rank. The recriminations toward both Short and Kimmel were not long in arriving. On December 17, 1941, Kimmel was relieved of duty and Admiral Chester W. Nimitz was placed in command of America's Pacific fleet. Kimmel was demoted to his permanent rank as rear admiral, testified at the Congressional and military investigative hearings that followed, and retired in 1942.

Kimmel and Short were criticized for failing to prepare adequately for a Japanese attack on Pearl Harbor, and their many detractors held them fully to blame. Others, however, saw both commanders as scapegoats. As time passed, there was speculation that President Roosevelt and his top advisors had baited the Japanese into the attack at Pearl Harbor so that America could have an excuse to enter World War II. There still is much murkiness regarding the truth of the matter, and over the years many other conspiracy theories have been advanced. Moving the American Pacific fleet from San Diego, California, and positioning it at Pearl Harbor in 1941 could be seen either as a logical defensive move given Japan's military alliance with Germany and Italy or as baiting a trap. Other events at issue include Kimmel interpreting orders that he received in November 1941 to initiate a "defensive deployment" to mean that he should defend against sabotage rather than move the fleet out to sea. Then there is the well-known decision to use the American carriers to ferry aircraft to Midway and Wake just at the time when that deployment would save them from destruction at Pearl Harbor.

The controversy swirling around the events that fateful Sunday morning in Hawaii has taken an endless series of twists and turns. One of the most interesting involved the military judgment about the bombing of Pearl Harbor later rendered by Admiral Nimitz, the man who followed Kimmel

in command. Nimitz is quoted as saying, "It was God's mercy that our fleet was in Pearl Harbor on December 7, 1941." The reason Nimitz said this was that he believed that had Kimmel ordered the fleet to leave the harbor without carrier cover from the Japanese carriers and subs, the likely result would have been the sinking of the American battleships in deep water, resulting in casualty numbers far exceeding those suffered on December 7. A second interesting twist involved the efforts made by Admiral Kimmel and his family to exonerate him from blame and restore his good name. In 1955, Kimmel published an autobiographical book asserting that he had been the scapegoat of a carefully crafted plot by President Roosevelt and other senior civilian and military officials to cover up their own more serious culpability for the attack on Pearl Harbor.

Kimmel died in 1968, still a bitter man. He was buried in the U.S. Naval Cemetery at Annapolis. The struggle to restore his name, however, has continued unabated. The Kimmel family has repeatedly petitioned presidents to have Admiral Kimmel's four-star rank reinstated. To date, none has done so. In 1995, a Pentagon study ascribed blame to a number of high-ranking officers for the failure at Pearl Harbor but in so doing did not exonerate Kimmel. Four years later, the U.S. Senate passed a nonbinding resolution exonerating Kimmel by a vote of fifty-two to forty-seven. This resolution also asked President Bill Clinton to promote Kimmel posthumously to full admiral, but the request was refused. While he is remembered as having been a major player on the world stage of history, Husband Kimmel's final role on that stage is still being debated.

Rose Monroe

1920–1997

"The 'We Can Do It' girl wasn't me."
Rose Will Monroe— "Rosie the Riveter"—from Pulaski County, Kentucky

The quintessential symbol for the special contributions women made to America's industrial productions efforts during World War II was "Rosie the Riveter," a contrived female publicity stunt that the federal government capitalized on to the fullest. Rose Will Monroe, who was born in Bobtown, Kentucky, in 1920, was working at the Willow Run Aircraft Factory in Ypsilanti, Michigan, building B-24 and B-29 bombers for the U.S. Army Air Forces in 1943 when she was noticed by actor Walter Pidgeon while he was making a bond drive appearance at the factory. Rose would become the personification of an unnamed girl portrayed in a poster, entitled "We Can Do It," by illustrator J. Howard Miller for Westinghouse done in 1942. Miller's poster (modeled by Geraldine Doyle, also a Michigan factory worker) profiles a female worker wearing a red polka-dotted bandana, defiantly flexing the muscles in her right arm, proclaiming "We Can Do It." However, Miller's work, and the iconic woman shown, should not be confused with the much broader image that the government created and would promote as Rosie the Riveter. The first, Miller's poster, dovetailed into the other, and though they are two separate concepts they have remained intertwined and fundamentally inseparable.

The name Rosie the Riveter became the wartime symbol for the willingness of women to leave their homes and join in the fight that was taking place. A popular song written early in 1943 by Redd Evans and John Jacob Loeby and performed by Kay Kaiser entitled "Rosie the Riveter" made it easy to transition this fictional character into the government's new female publicity agent, Rose Will Monroe. Following her discovery by Walter Pidgeon, Monroe appeared in a film promoting the purchase of war bonds shown in theatres nationwide and for a short time did publicity for other government

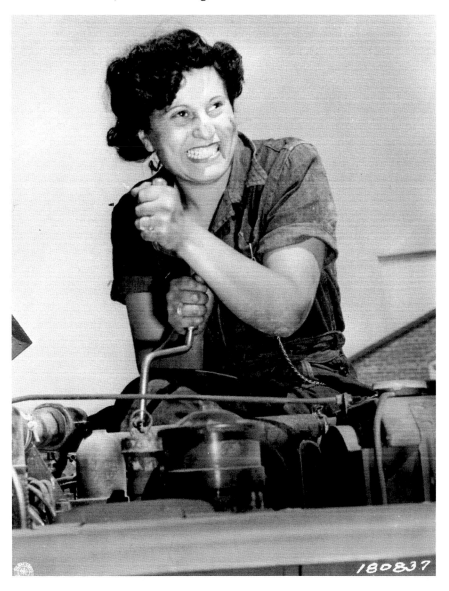

Rose Monroe ("Rosie the Riveter"). *Courtesy of the Library of Congress.*

bond drives and promotions. It did not last long. The bonds were sold, Rose kept on working and the war was won.

Monroe, a widow with two daughters to support, never capitalized on her brief brush with fame. After the war, she continued working, often in jobs normally reserved for men. She drove a cab, founded and ran a construction company and, deviating from her "males-preferred" work choices, operated

a beauty shop. At age fifty, she fulfilled a lifelong dream and began to fly airplanes. It almost cost Rose her life, as in 1978 she crashed a small prop plane during takeoff and suffered injuries from which she never fully recovered. Monroe died at age seventy-seven in her home at Clarksville in Floyd County, Indiana, and was buried in the Floyd County Cemetery.

Rosie the Riveter, a symbol representative of the twenty million women who worked in war plants, remains an American cultural icon. Despite the confused association with the "We Can Do It" female factory worker created in J. Howard Miller's poster, Rosie the Riveter took on a life of her own, far removed from the one Rose Monroe led later. Rosie the Riveter has been the subject of pop art, has been written about in books, magazines and newspapers, has been portrayed in educational television programs about Rose Monroe and World War II and was portrayed in a Norman Rockwell painting featured on the cover of the *Saturday Evening Post* in 1943 that was auctioned by Sotheby's for $4,959,500 in 2002. Given what she overcame—a widow working in a factory while having to raise two daughters, doing men's work in times when this was quite uncommon—it is altogether fitting that Rose Will Monroe was chosen to represent the American female factory workers who helped to win the war by making America the "arsenal of Democracy."

Franklin Sousley

1925–1945

"The flag just went up on Iwo."
Marine Private First Class Franklin Sousley—one of the seven servicemen pictured in
the Pulitzer Prize–winning combat picture of the flag raising at Mount Suribachi on the
Japanese held island of Iwo Jima—from Flatwoods, Kentucky

Franklin Runyon Sousley, a nineteen-year-old farm boy from Kentucky, will forever be known as one of the seven servicemen in Joe Rosenthal's photo of the American flag being raised at Mount Suribachi, thought to be the most famous photo of all time. Franklin Sousley graduated from high school in Kentucky, after which he took a job with the Frigidaire Division of General Motors in Dayton, Ohio. He joined the marine corps in 1944 and, after completing basic training, was assigned to duty at Camp Pendleton in California. Sousley, an automatic rifleman, was assigned to Company E, Second Battalion, Twenty-eighth Marines of the Fifth Marine Division, his only military posting. He sailed with his battalion in September 1944 to Hawaii and, after extensive training and promotion to private first class, was in the invasion force that landed on the Japanese-held island of Iwo Jima on February 15, 1945. Sousley was among the combat marines who took Mount Suribachi after bitter hand-to-hand fighting and, along with five other marines and one naval corpsman, helped raise a large replacement flag atop the hill so that Joe Rosenthal could photograph the re-created event.

The importance of the flag going up on Mount Suribachi, Iwo Jima's highest volcanic crest, was immediately recognized as a propaganda tool, but before they could be removed from combat Sousley and two of his fellow marines pictured in the flag raising were killed. Sousley was shot in the back by a Japanese sniper while walking down the middle of an open road near Kitano Point. He died minutes later. Sousley was buried on Iwo Jima and in 1947 was reburied in a cemetery located near his birthplace in Kentucky. In a letter he had mailed to his mother just before his death,

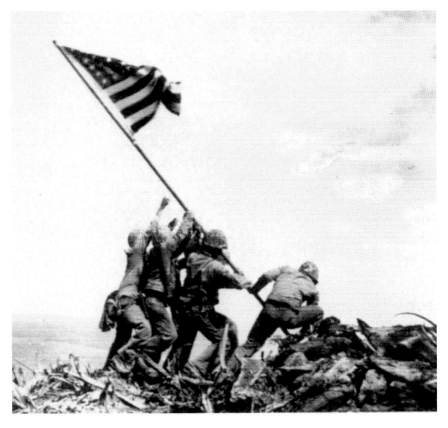

Franklin Sousley, pictured second from the top. *Courtesy of the U.S. Navy.*

Sousley wrote, "My regiment took the hill with our company on the front line. The hill was hard, and I sure never expected war to be like it was those first four days. Mother, you can never imagine how a battlefield looks. It sure looks horrible. Look for my picture because I helped put the flag up. Please don't worry and write."

Sousley is among those featured in Clint Eastwood's 2006 film *Flags of Our Fathers*. A fellow marine visited Sousley's grave in Kentucky during the early 1990s and was appalled that Sousley had been laid to rest under a tiny headstone with no special commemoration of his role in the raising of the flag. A drive to correct this was undertaken in Sousley's home county, and a commemorative monument to the hometown hero was dedicated in 1995 on the fiftieth anniversary of the flag being raised atop Mount Suribachi.

Victor Mature

1915–1999

"Next time, make it a light trim Delilah."
Victor Mature—movie star and stage actor—from Louisville, Kentucky

Sometimes an actor or actress just seems fated to play a particular acting role, as was the case when Louisville, Kentucky native Victor Mature was cast in 1949 as the legendary Biblical strongman Samson in Cecil B. DeMille's classic movie *Samson and Delilah*. DeMille originally tried to cast Burt Lancaster in the role of Samson, but after Lancaster refused the part, DeMille decided upon Mature instead. Mature, the son of an immigrant knife sharpener, had been discovered in 1939 while stage acting at the Playhouse in Los Angeles. By 1949, Mature had appeared in twenty-eight movies and was being billed as "the Handsome Hunk" because of his imposing physique and rugged good looks.

Mature never took his acting too seriously, often dismissing his roles in movies as merely "grunt-and-groan parts." In 1949, however, he was at the peak of his career and a logical substitute to play the movie role of Samson. Sultry Hedy Lamarr was cast as the temptress Delilah, and although some critics characterized the film's acting as "not good" and the dialogue as "not sparkling," the movie was a substantial box office success and remains a "camp classic." One scene in the movie called for Samson to wrestle and slay a lion with his bare hands, but when Mature refused to wrestle a tamed live lion and insisted instead on fighting a tacky dummy, DeMille became furious. Always casual about his acting abilities and roles, Mature did not seem to care one whit about making DeMille angry. After the movie became a box office success, the director forgot and forgave; later he gave Mature the lead role in another box office hit, the 1953 Biblical classic *The Robe*.

Mature made twenty-six films after *Samson and Delilah* and one television movie before retiring. He was married and divorced five times and divided his time, during his career and while in retirement, between his homes in

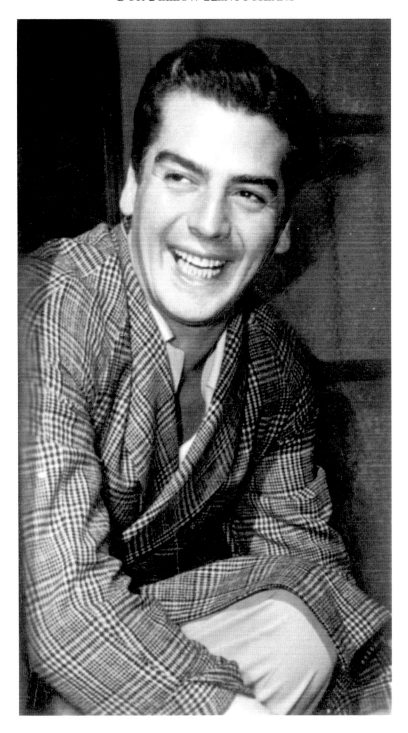

Victor Mature. *Courtesy of Special Collections & Archives, University of Kentucky.*

California and Louisville. There was one incident, while he was in Louisville, that seems likely to assure Mature a measure of local immortality. When a country club in town refused him membership because of his profession, Mature good-naturedly responded, "Hell, I'm no actor, and I've got a scrapbook of reviews to prove it." Mature died in 1999 of leukemia at age eighty-six at his Rancho Santa Fe, California home; he is buried in Louisville. His lone acting award is a star dedicated in his name on the Hollywood Walk of Fame.

Loretta Lynn

1934–present

"Daddy was a coal miner, and I'm a coal miner's daughter."
Loretta Webb Lynn—reigning queen mother of country music—from Butcher Holler,
Johnson County, Kentucky

Loretta Lynn was born in her family's farmhouse located in the mountains of eastern Kentucky on April 13, 1934. She was the second of eight children. The Webb family was a family of singers, from which four children—sisters Loretta, Gail and Peggy Sue and their brother Jay Lee—would become recording artists. Named for Loretta Young, her mother's favorite actress, Loretta walked several miles daily to attend the one-room Miller's Creek School in nearby Van Lear, where she completed the eighth grade. Her father, Melvin, as Loretta's later hit song says, was a coal miner who "worked all day in the Van Lear mines."

At age thirteen, Loretta met Oliver "Mooney" Lynn, an ex-soldier seven years her senior, and one month later she married him. Soon after their marriage, they moved to Custer, Washington. Mother of four by the age of eighteen, Loretta learned to play a twenty-dollar guitar while singing lullabies. Urged on by her husband, Lynn cut a demo record, which the couple promoted by driving to area radio stations and asking disc jockeys to air it. Some did and some did not, but it got enough air time for a radio station, KPUG in Bellingham, Washington, to ask Loretta to make a five-minute on-air appearance in 1960—a performance that propelled Lynn into a professional career as a regular on Nashville's "Grand Ole Opry" and eventual recognition as country music's first lady.

While on the Opry, Loretta met Patsy Cline, the Opry's reigning queen of country music, who became her best friend. Cline died in a plane crash in 1963, an event Loretta would help immortalize in an album that she later released entitled "I Remember Patsy." Loretta, who continues to perform, has recorded over sixty singles and over one hundred albums for Decca and MCA, many

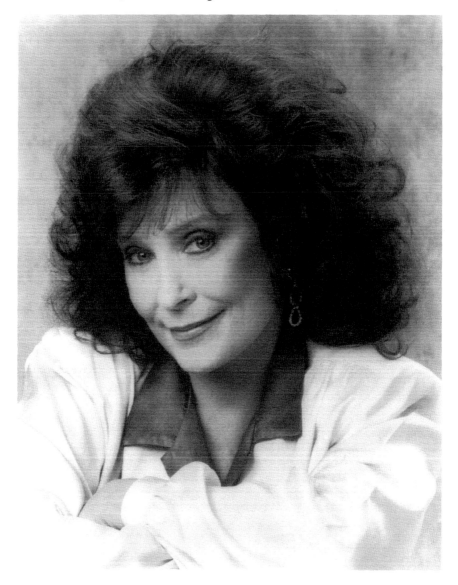

Loretta Lynn. *Courtesy of Peter Nash.*

of the songs her own compositions. She has two daughters, Peggy and Patsy Lynn, who are also successful recording artists. Lynn's sister Gail performs as Crystal Gayle. Reputedly, Gail's performing name was developed as the two sisters sat at a kitchen table. Loretta, it is said, urged Gail to adopt the more artistic spelling of "Gayle" and then told her to precede it with "Crystal" after telling her sister it was because "you sure do like them Crystal Hamburgers."

Loretta Lynn's honors include a Grammy; multiple nominations and three awards from the Country Music Association as top female artist; two awards from *Record World*; three from *Billboard*; and four from *Cash Box*. In 1972, Lynn was the first woman selected Country Music Association Entertainer of the Year; in 1980, she was named entertainer of the decade. Her best-known songs include: "I'm a Honky Tonk Girl" (1960), "Blue Kentucky Girl" (1965), "You Ain't Woman Enough" (1966) and "You're Looking at Country" (1971). The 1980 movie *Coal Miner's Daughter* was based on her autobiography.

Typically, Lynn's songs are lyrical and send strong but simple messages. One of her more recent recordings, "Van Lear Rose," which expands the story of Lynn growing up the daughter of a miner in a coal mining community, is typical of this. As for Loretta, you seemingly cannot take the country out of a country girl. Although she makes her home in Nashville, Loretta regularly returns to Butcher Holler and adjoining Webb Holler to visit relatives and might be seen sitting on the porch of her childhood home with her brother Herman, or visiting the nearby general store that is filled from top to bottom with Loretta Lynn memorabilia.

Duncan Hines

1880–1959

"Duncan, please pass the cupcakes."
Duncan Hines—famed food critic, author and processed food marketer—from Bowling
Green, Kentucky

He traveled, cooked and wrote his way to fame—his name was Duncan Hines. The son of Edward L. and Cornelia Duncan Hines, Duncan Hines was born in Bowling Green, Kentucky, in 1880. He graduated high school, after which he briefly attended what was at the time known as Western Kentucky State Normal School in his hometown before dropping out to take a job in the printing and advertising business in Chicago, Illinois. From 1905 until 1935, Hines was a traveling salesman for Rogers and Company Printers. He and his first wife, Florence, traveled nationwide for thirty years, stopping along America's archaic highway system to dine at restaurants, some good and some bad. At the time, there were no published standards governing kitchen sanitation or food safety, food poisoning was quite common and travelers ate out at their own peril.

In 1935, Hines and his wife sent their friends a Christmas mailing that listed 167 restaurants they ranked as "superior eating places." Out of this list grew Duncan Hines's first book, *Adventures in Good Eating* (1936), and his career as a traveling food connoisseur was launched. In 1938, Hines published a companion work, *Lodgings for a Night*, and expanded his knowledge base further in 1939 with the publication of his first cookbook. It was at this point that restaurants and inns across America began enticing customers with signs proclaiming that their establishments had been "Recommended by Duncan Hines." Hines's endorsement and his reputation of not taking any compensation for his recommendations helped usher in a new era of consumer trust in America's restaurant and lodging industries.

By the 1940s, Duncan Hines had become an American celebrity. He was featured on a daily Mutual Network Radio broadcast, and his weekly opinion

column appeared in one hundred newspapers nationwide. It was estimated that twenty million readers regularly read Hines's column. Understandably, restaurants and lodging facilities clamored to get his endorsement, which was known to be based on thoughtful and fair evaluation. For many businesses it could well have been the difference between success and failure. On one occasion, Hines visited a small café in Corbin, Kentucky, operated by Harland Sanders, long before Sanders would become a celebrity in his own right, and proclaimed it to be "a good place to eat."

In 1947, Hines formed a partnership with Roy Park known as the Hines-Park Food Corporation, a business venture that made both men millionaires. The new corporation featured an ever-expanding line of kitchen-related products ranging from pickles to appliances. At its zenith, the company had nearly two hundred Duncan Hines brands on grocery store shelves and marketed fifty different kitchen tools and appliances. In the mid-1950s, Hines-Park Foods sold its highly profitable line of Duncan Hines cake mixes to corporate giant Procter and Gamble, which expanded the business to the nationwide market and added a series of related baking products. Today, the Duncan Hines brand, which since 1998 has belonged to Pinnacle Foods, features a line of cake, brownie, muffin and cookie mixes and canned frostings.

Florence Hines died in 1939. Duncan moved back to Bowling Green in 1940, remarried in 1946 and lived there with his second and then third wife until he died from lung cancer in 1959. He and Parks founded the Duncan Hines Institute, a facility that conducted food research and provided students with scholarships to study hotel and restaurant management. Hines is fondly remembered by the residents of Bowling Green, Kentucky, as both personable and generous. Soon after his death, his hometown named a portion of U.S. Highway 31 West north of the city the Duncan Hines Highway. Western Kentucky University has become a repository for Hines artifacts and information about his career and has erected a permanent display commemorating the contributions he made to American culture.

Harland Sanders

1890–1980

"I recommend the chicken dinner, it's our specialty."
Colonel Harland Sanders—originator of Kentucky Fried Chicken—from Corbin,
Kentucky

They say necessity is the mother of invention, and the life and career of Harland Sanders, the creator and franchiser of Kentucky Fried Chicken, is solid evidence of this adage. Harland David Sanders was born in southern Indiana in 1890. His father died when Harland was six years old and his mother worked, so Sanders had to care for his brother and sister and learn to cook, a skill he quickly mastered. Sanders dropped out of school after the sixth grade and ran away from home at age twelve because his mother's new husband beat him.

Over the next few years, Sanders held many jobs, including farm worker, tire salesman, service station operator, river ferry pilot, insurance salesman and railroad fireman. He even worked for a justice of the peace and briefly studied law by correspondence. At age sixteen, Sanders lied about his age and entered the army as a private. His military service lasted for six months, all of it in Cuba.

By 1930, Sanders was operating a service station located on the busy junction of U.S. Highway 25, 25 West and 25 East in Corbin, Kentucky. Sanders began applying his cooking skills there by preparing meals for hungry travelers who had stopped for gas. Initially, customers ate at Sanders's own dining table, and soon Sanders began offering patrons carryout boxes of food to take with them as they continued on their journeys. After his food business had grown, Sanders moved it across the road to a motel and restaurant that could seat 142 people. His specialty was fried chicken, and over the next nine years Sanders would perfect a secret blend of eleven herbs and spices (ingredients that he boasted could be found on every kitchen's pantry shelves) that would give what became known as Kentucky Fried Chicken its unique taste.

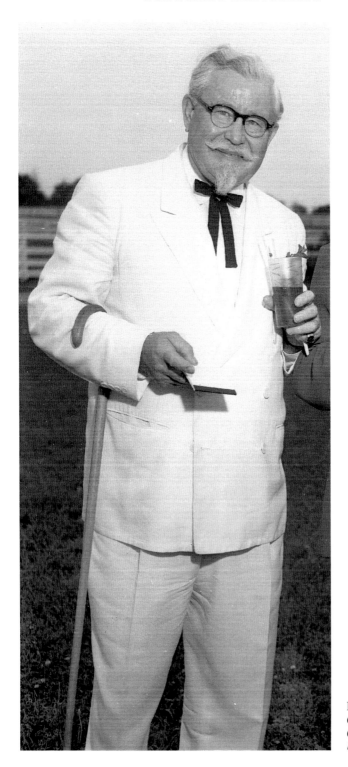

Harland Sanders.
*Courtesy of Special
Collections & Archives,
University of Kentucky.*

Rascals, Heroes and Just Plain Uncommon Folk

Plans in 1952 to build a new interstate bypassing his business caused Sanders to close up shop and auction off his holdings. His only remaining income was his $105 monthly social security check; he was sixty-five years old and once again left to live by his wits to survive. Sanders took his $105 and hit the road, hawking his pressure fried technique of preparing chicken, which utilized his secret recipe of herbs and spices. Sanders, along with his wife Claudia, traveled by car across America from restaurant to restaurant cooking up batches of his "southern-style" fried chicken and offering it for tasting to owners and employees.

Though likely an exaggeration, it was said later that Sanders suffered three thousand rejections before he made his first sale. Sales were consummated by a handshake and a promise that Sanders would receive a nickel for each chicken dinner sold. Having been commissioned a Kentucky colonel in 1935, Sanders introduced himself to prospective customers as "the Colonel," dressed stereotypically as a "southern gentleman" replete with a goatee, white suit, string tie and walking stick. He hawked a product that he had christened "Kentucky Fried Chicken." This sales odyssey must have exceeded even the Colonel's wildest dreams, for by 1964 there were more than six hundred outlets selling Kentucky Fried Chicken in Canada and the United States. One of Sanders's district managers in Ohio, Dave Thomas, left the Colonel's company and founded Wendy's. Later, when the Colonel passed away, Thomas ordered that flags in front of all of Wendy's restaurants be flown at half-mast.

Sanders sold his U.S. interests in 1964 to a group of investors for $2 million but retained his holdings in Canada. He was a paid public spokesman for the corporation, now known as KFC, until his death in December 1980, and Colonel Sanders's image is still featured on the company's marketing products. An independent survey conducted in 1976 ranked Colonel Sanders as the second most recognizable celebrity in the world, and another ranked Kentucky Fried Chicken the world's third most recognizable marketing name, trailing only Coca-Cola and IBM, which ranked first and second, respectively. Currently, there are over eleven thousand KFC restaurants located in more than eighty countries. The Colonel's "finger-lick'n good" chicken, made from his closely guarded secret recipe of herbs and spices, remains an iconoclastic corporate symbol, one built on the hard work and grit of a truly amazing individual, Colonel Harland B. Sanders.

Lelia Busler

1921–1981

"Oh Frank." "Oh Margaret—Shhh—here comes Hawkeye."
Captain Lelia Jeanette Jones Busler—thought to be the actual "Hot Lips" Houlihan,
*the zany fictional nurse portrayed in the M*A*S*H trilogy—from Irvine, Kentucky*

One of the more lasting impressions of the Korean War was created by the popular book, movie and television series *M*A*S*H*, the 8055th (Double Nickel) Mobile Army Surgical Hospital. Among the cast of fictional characters portrayed in *M*A*S*H* was Major Margaret "Hot Lips" Houlihan, the beleaguered neurotic commander of the nursing unit attached. Lelia Jones Busler's connection to the *M*A*S*H* trilogy is linked to her service as a young nurse with the 8055th in Korea from July 1951 to January 1952. Busler's successful career as an army nurse, which spanned nearly three decades, is overshadowed by the portrayal of her as Hot Lips Houlihan in the book *MASH: A Novel About Three Army Doctors*, written by Dr. H. Richard Hornberger, who was Lelia's lover and commanding officer in Korea.

Lelia Jones was born in Irvine, Kentucky, in 1921. She graduated from high school in 1939, and after completing a thirty-six-month nursing program in Ohio she became a registered nurse. Jones joined the Army Nurse Corps in April 1943, gaining entry only after consuming several dozen bananas in order to increase her body weight. She was commissioned a second lieutenant in 1945 and attained the rank of captain by 1951. In the spring of that year, Jones was given orders to report as a general duty nurse to the 8055th (MASH) at Uijongbu, Korea.

Lelia (or "Little Bit," as she was known) was an excellent nurse. She was talkative and moody, a beautiful woman with curly brown hair and hazel eyes. The baggy fatigues she wore could hardly conceal her great figure, and it did not take Colonel Hornberger, her commanding officer, long to notice this striking "southern beauty." Jones also never wore a bra, something that

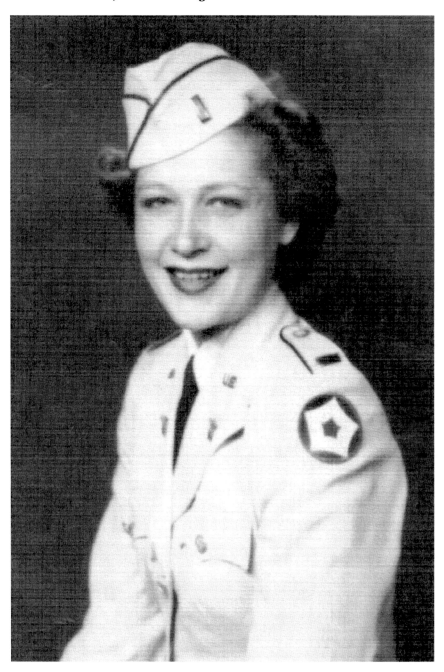

Lelia Busler. *Courtesy of John Trowbridge.*

was considered quite risqué at the time. One thing led to another, and soon Jones and Hornberger, who was married, were involved in a torrid, and not so secret, love affair that did not survive the war. When Hornberger returned home to his wife and family, he resumed his medical practice but could not put either his surgical or romantic experiences in Korea out of his mind. With a burning desire to chronicle his MASH unit's wartime experiences in Korea, Hornberger sat down to write a book, one containing so many elements of truth that he decided to use a pen name of Richard Hooker rather than his own. Accordingly, *MASH* the novel, *M*A*S*H* the movie and *M*A*S*H* the popular television series were born.

Lelia, whose married name was Busler, put this segmented part of her military career and the clandestine love affair in Korea behind her and went on to a distinguished career in the Army Nurse Corps. Her later military nursing duties included postings throughout the United States and Europe. By 1968, she held the rank of lieutenant colonel and was chief of nursing services at Weed Army Hospital at Fort Irvine, California. Shortly thereafter, she was appointed the U.S. Army's acting chief nurse of nursing services. Busler was, in fact, thought by colleagues to be positioned to become the chief nurse of the Army Nurse Corps. However, after having been promoted to colonel in the 1970s, her promising military career was cut short by an ongoing struggle with COPD, a smoker's ailment aggravated by the lung condition she had contracted in Korea.

Busler retired from active military duty on June 30, 1973, after having completed twenty-eight years of honorable service. She settled in Richmond, Kentucky, where she did volunteer work at a religious bookstore. Busler died of pulmonary failure at the Veterans Administration Hospital in Lexington, Kentucky, on May 29, 1981.

Hooker's book, which was published in 1968, was the basis for the movie *M*A*S*H* and the television series *M*A*S*H*, which aired from 1972 until 1983 and can still be seen on television reruns. Busler's connection to the *M*A*S*H* stories was essentially ignored until a recent series of writings chronicled her affair with Hornberger and suggested her having been the basis for the character of Hot Lips Houlihan. While there is now good reason to believe that Lelia Busler inspired the fictional character of Major Margaret Houlihan, neither Busler nor Hornberger ever confirmed that assumption.

Kelly Coleman

1938–present

"I was only a teenager, and already they were calling me 'King.'"
"King" Kelly Coleman—considered the greatest high school player in Kentucky basketball history—from Wayland, Kentucky

Imagine what it must have been like to grow up in the remote mountains of Kentucky, the son of a coal miner barely scratching out a living for his wife and the family's ten other children, and then one can begin to comprehend where Kentucky's greatest high school basketball player, "King" Kelly Coleman, began. In southeastern Kentucky, Wayland, which today has a population of six hundred, was once a thriving community of over two thousand. The entire town was owned by Consolidated Coal, and those who worked in the mines, as the famous mining song "Sixteen Tons" proclaims, truly "owed their souls to the company store."

Playing basketball was one way to escape from the subsistence life that mining families faced, and from a very early age Kelly Coleman understood this. Strong and six feet, two inches in height, Coleman, who wore the number 66 on his uniform, played four years of high school basketball for the Wayland Wasps, perfecting his playing skills to a level few heretofore had achieved. His statistics were eye-catching: during his freshman year, 1952–53, he played in twenty games, averaging 19.3 points; in 1953–54, in thirty games, he averaged 26.1 points; in 1954–55, in thirty-six games, he averaged 32.6 points; and in 1955–56 he played in thirty-seven games, averaging 46.8 points.

Already a legend in the mountains as well as statewide in Kentucky, in 1956 Coleman led the Wayland Wasps to a third-place finish in the Kentucky High School Basketball Tournament, establishing the existing four-game record for total points (185) and single-game points (68). Kelly's nickname, King, was given to him by "Red" Morgan, a Prestonsburg, Kentucky sportswriter who, in his enthusiasm for Coleman's basketball skills, hired a helicopter to

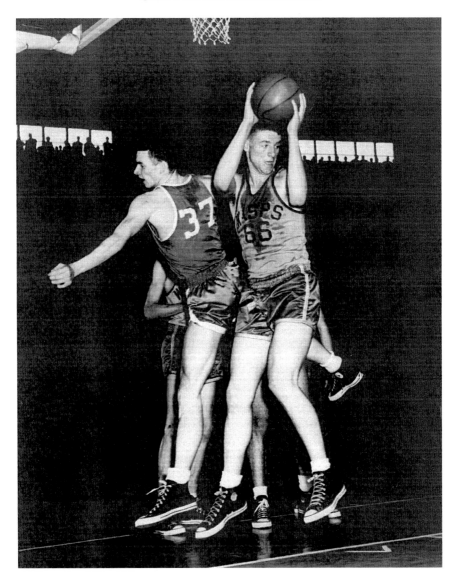

Kelly Coleman. *Courtesy of the Wayland Historical Society.*

fly over Lexington on the day of Wayland's first-round tournament game and drop ten thousand yellow leaflets proclaiming "the King is here!"

This seemed to turn the crowds against Coleman, who, despite his remarkable ball-handling, shooting and rebounding skills, was soon being booed each time he handled the ball. For a shy youngster whose life in the mountains was sheltered, it was too much to expect that Coleman would

take all this in stride. At the close of the tournament, Coleman was absent when he was named Tournament MVP and his teammates received the third-place trophy. He remained bitter about his treatment for years. Later that year, Coleman was designated a High School All-American and became Kentucky's first official "Mr. Basketball." Two heavily hyped Indiana-Kentucky Basketball All-Star Games that year matched Coleman up against the Indiana state champion, Indianapolis Crispus Attucks's phenomenal guard Oscar Robertson, but both games were anticlimactic, as Coleman's ankle was severely swollen, and he saw limited action.

It had been speculated that Coleman might decide to play basketball for the University of Kentucky, but his treatment in Lexington ended all such speculation. Instead, he went first to Marshall University in West Virginia and then to Eastern Kentucky University, before going on to become a two-time All-American at Kentucky Wesleyan University in Owensboro, Kentucky, after which he was taken by the New York Knicks as the ninth player selected in the first round of the 1960 NBA draft. Coleman, who liked to drink whiskey and beer when he was in high school and college, also had developed attitudinal problems about authority that led to a dispute with his coach and his dismissal from the Knicks.

Following his firing by the Knicks, Coleman became a star in the short-lived American Basketball League. After that league folded in 1963, Coleman barnstormed with the Harlem Globetrotters. Later, he worked a number of years at the *Detroit Free Press* and, after retiring, returned to Wayland, where he now lives. The narrow, winding stretch of highway that leads in and out of Wayland is called the Kelly Coleman Highway. Always reticent about his baseketball accomplishments, Coleman has mellowed with age and seems more willing to accept praise and adulation from those who recall him as King Kelly Coleman, the king of Kentucky high school basketball.

Muhammad Ali

1942–present

"Float like a butterfly, and sting like a bee, Ali's World Champion for time number three."
Muhammad Ali—former world heavyweight boxing champion—from Louisville,
Kentucky

Self-styled master of rhymes, homespun philosopher and three-time world heavyweight boxing champion, Muhammad Ali was born in Louisville, Kentucky, in January 1942. His father (Cassius Marcellus Clay Sr.), a billboard and sign painter named for the nineteenth-century emancipationist and politician of that name, and his mother (Odessa), a household domestic, named their son Cassius Marcellus Clay Jr. Growing up and playing on the streets of Louisville, Clay encountered several problems. Besides fights with neighborhood boys and having to put up with racial slurs from young whites, Clay had his bicycle stolen when he was twelve, and at the urging of Joe E. Martin, a city policeman, took up boxing to learn to protect himself and his belongings.

Clay was a natural as a boxer. He won six Kentucky Golden Gloves titles, two national Golden Gloves titles, an Amateur Athletic Union title and the light heavyweight gold medal in the 1960 Summer Olympics in Rome. Later, Clay said he threw the gold medal in the Ohio River after having been refused service in a Louisville restaurant and after being attacked by a gang of local whites. As an amateur, Clay had one hundred wins and five losses. His first professional fight took place on October 29, 1960, a bout in which Clay won a six-round decision over Tunney Hunsaker, the police chief of Fayetteville, West Virginia. Clay signed up for this fight on his own, and his share of the purse was $2,000.

Clay signed a contract to fight for the Louisville Sponsoring Group after the Hunsaker fight. However, he only earned a total of $2,303 from his next four professional fights, all victories. Clay stood six feet, three inches tall and possessed remarkable hand and eye coordination as well as tremendous

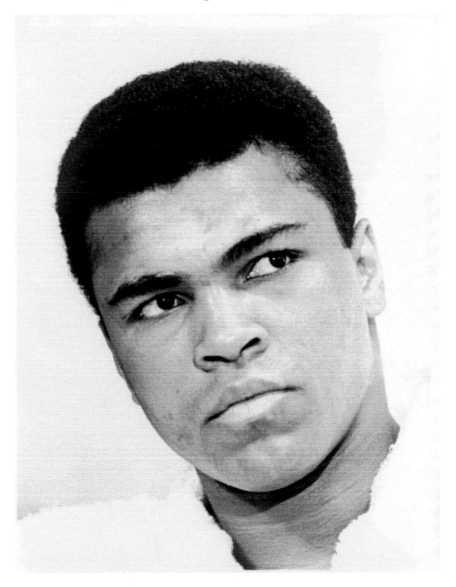

Muhammad Ali. *Courtesy of the Library of Congress.*

foot speed. He fought in an unorthodox way, with his hands lowered, taunting opponents to try to catch up with him and to hit him in the face. This unorthodox style of boxing Clay later characterized as "floating like a butterfly and stinging like a bee."

From 1960 to 1963, Clay compiled a professional record of 19–0, with five knockouts. Clay often predicted the round in which he would defeat

his opponent, a brashness that would soon earn him the sobriquet "The Louisville Lip." In the last fight in his string of nineteen victories, Clay fought Henry Cooper in London, England. Cooper caught Clay with a solid left hook near the end of round four, sending Clay sprawling to the canvas. Clay came out in round five with "blood in his eyes," pummeling Cooper relentlessly until the referee stopped the fight because of the deep cuts over Cooper's eyes.

The stage was set for Clay's first title fight, a heavyweight match on February 25, 1964, in Miami Beach, Florida, in which Clay was no less than a seven to one underdog against the world titleholder, Sonny Liston. True to his character as a showman, Clay predicted victory and taunted the champ at the weigh-in, uttering his colorful butterfly and bee axiom, dubbing Liston "the big ugly bear" and warning the champion, "Your hands can't hit what your eyes can't see." Liston, it turned out, was overmatched. Clay nimbly danced away from Liston and jabbed while the hapless champion expended his energies chasing the challenger about the ring. When the bell rang for the seventh round to begin, Liston stayed in his corner, later explaining that he had hurt his shoulder. To the consternation of the fight fans, who disliked Clay for his brashness and boasting, the Louisville Lip had just become the heavyweight champion of the world!

The behind-the-scenes scuttlebutt was that the fight with Liston had almost been cancelled when promoter Bill Faversham discovered that Clay had been seen associating with militant black leader Malcolm X and that Clay was about to become a convert to the Nation of Islam (often called the Black Muslims at this time). Clay, understanding that his ties to Malcolm X could hurt the fight's gate, agreed to delay announcing his religious conversion until after his match with Liston. After winning the championship, however, Clay (who proclaimed that he was shedding his "slave" name, that of a man who had once held slaves) announced his conversion to Islam and was given the name Cassius X by the Nation. The movement's real leader, Elijah Muhammad, completed the renaming of Clay by giving him the name Muhammad (one who is worthy of praise) and Ali (for the fourth rightfully guided caliph).

Between 1964 and 1967, Ali successfully defended his title nine times, winning seven of these bouts—including a rematch with Sonny Liston—by knockouts. Politics and Ali's unwavering and controversial adherence to his newfound religious principles were about to strike a blow to the champion that no contemporary fighter could. In spring 1967, Ali received a draft notice. He refused induction into military service based on his religious beliefs, was tried, convicted, fined $10,000 and sentenced to five years in

jail, after which he was stripped of his title by the boxing commission and banned from boxing. Ali never went to jail but did spend three years exiled from boxing. He was reinstated in 1970 and began his quest to regain his heavyweight title by defeating two opponents, then lost a fifteen-round decision to Champion Joe Frazier, after which Ali reeled off ten more victories, six by knockouts.

Ali, now thirty-one years old but still supremely confident in his abilities, agreed to fight Ken Norton on March 31, 1973, in San Diego, California. Facing a decidedly hostile crowd, Ali was about to reach another turning point in his storied boxing career. Looking smug and self-confident, wearing a robe proclaiming him "The People's Champion" given to him by Elvis Presley, Ali had failed to train for this fight properly and it quickly showed. A crushing left hand broke Ali's jaw in the first round, and though he fought bravely on, Ali lost the twelve-round decision. The loss put Ali's wife, Belinda, who screamed uncontrollably "You have killed Ali," in a hospital mental facility, and it left Ali sobered but resolute to make amends by defeating Norton in a rematch. Six months later, fully recovered and razor sharp, Ali defeated Norton in a twelve-round decision in Los Angeles, California, launching a new drive by Ali to regain his world heavyweight boxing title.

On October 30, 1974, after winning two more fights, Ali faced heavyweight champion George Foreman in Zaire, Africa, in what promoter Don King had labeled the "Rumble in the Jungle." Again, Ali was the decided underdog and again he confounded the experts and won. Foreman threw hundreds of punches in seven rounds and Ali took them and let the champion chase him about in a tactic Ali later explained colorfully as the "Rope-a-Dope." Ali caught his exhausted opponent with a combination in the eighth round that put the champ down and unable to rise and beat the count. At age thirty-two, Muhammad Ali was heavyweight champion of the world for a second time, this time receiving a record-setting $5,450,000 payoff for the win.

Ali remained the world heavyweight champion until February 1978, when he was defeated by 1976 Olympic Champion Leon Spinks. Along the way, Ali participated in what many regard as the greatest heavyweight boxing match of all time, the September 1975 "Thrilla in Manila," which Ali won on a TKO over George Frazier in fourteen rounds. Ali avenged his loss to Spinks, regaining his title in September 1978 by unanimous decision, thus becoming the world heavyweight champion for a third time. In his last fight, against Larry Holmes in 1980, Ali was knocked out. Boxing has taken a toll on Ali, as he now suffers from Parkinson's syndrome. In his professional career, Ali won fifty-six of sixty-one fights, thirty-seven by knockouts; his

career earnings were well in excess of $30 million. With his mouth, speed and grace, Ali brought new dimensions to heavyweight boxing. That he helped to revitalize the sport of boxing in modern times is unquestionable—Ali's exact place among the greatest boxers of all time is still being argued.

Helen Thomas

1920–present

"Thank you, Mr. President."
Helen Thomas—reporter and columnist—from Winchester, Kentucky

White House reporter Helen Thomas, who was born in Winchester, Kentucky, delivered the line, "Thank you, Mr. President," at the close of each White House press conference beginning in 1961 with President John F. Kennedy and lasting through the end of President Bill Clinton's second term in 2000. Thomas, who routinely was called upon by this period's presidents to ask the first question at White House press conferences and briefings, assumed the role of a quirky and iconoclastic presence who, with her patented closing of "Thank you, Mr. President," became the reporter who heralded a session's closing.

Helen Thomas began her career in journalism as a copygirl for the now-defunct *Washington News*. She was hired by United Press International in 1943 to report on women's issues for UPI's radio wire services. During the mid-1950s, she wrote a column titled "Names in the News" and subsequently was assigned to cover federal agencies for UPI. Her major journalistic break came in November 1960, when she was assigned to cover President-elect John F. Kennedy.

It was obvious that Kennedy liked Thomas, so in January 1961 UPI made her its White House correspondent. The ubiquitous interplay between Kennedy that followed soon became a smirk-provoking "inside joke" with the White House Press Corps as Thomas routinely was the first reporter called upon by Kennedy for a question and always the one who closed the conference with what would become her patented presidential closing line. This routine, which lasted forty years, gave Thomas access and "an insider's view" to other White House information. Thomas's thoughts about all of this could be found in her column for UPI, "Backstairs at the White House."

Helen Thomas. *Courtesy of the Library of Congress.*

On May 17, 2000, Thomas resigned her position with UPI after the news organization was bought by a corporation controlled by the Reverend Sun Myung Moon, a change in ownership that Thomas characterized as being "a bridge too far." Thomas, who is now in her mid-eighties, has been experiencing declining health. Nonetheless, she continues to report. During George W. Bush's presidency (2001–09), Thomas, who no longer worked for a major news service, was relegated to a seat in the back row at White House press briefings. However, even while seated in the back, she still had an impact. During two press briefings in 2006 and 2007, President George W. Bush was questioned aggressively by Thomas about his administration's policies in Iraq and Iran, later causing presidential aides to mark the place on the seating chart where Thomas would be sitting with an "X." Thomas's front-row seating at White House briefings was restored by the Obama administration in 2009, but she has not yet been called upon to deliver her famous closing line.

Diane Sawyer

1945–present

"That's one blonde that sure knows what she's doing."
Diane Sawyer—journalist and television correspondent—from Glasgow, Kentucky

Lila Diane Sawyer, the daughter of E.P. and Jean Dunagan Sawyer, was born in 1945 in Glasgow, Kentucky. Her father, a Jefferson County Republican judge/executive, was killed in an auto accident in 1969, and a state park in the Louisville area, the E.P. "Tom" Sawyer Park, is named for him. After graduating from Wellesley College in 1967, Diane began working as a news reporter and weather girl at WLKY-TV, a CBS affiliate, in Louisville. In 1970, she moved to Washington, D.C., hoping to land a job in broadcasting. She was hired that year by fellow Kentuckian Ron Ziegler, President Richard Nixon's press secretary, as an assistant to Jerry Warren, the White House deputy press secretary.

Sawyer began her work in the White House writing press releases; this job soon evolved into drafting public statements for President Nixon. Promoted to staff assistant to the president, Sawyer was responsible for monitoring media coverage during the Watergate scandal. After Nixon resigned in August 1974, Sawyer accompanied him to San Clemente, California, where she helped the former president research his memoirs. Years later, Sawyer was one of those persons mentioned as being "Deep Throat," the informant who had helped topple Nixon, but this was shown not to be the case.

In 1978, Sawyer became a political correspondent at CBS, and then in 1981 became the co-anchor, along with Bill Kurtis, of the *CBS Morning News*. Attractive and a far call from fulfilling the stereotypical image of being a "dumb blonde," Sawyer has steadily won respect for her interviewing skills and her professional approach to journalism. Her highly praised coverage of the nuclear disaster at Three Mile Island in Pennsylvania in March 1979 resulted in Sawyer being promoted to correspondent by CBS news in 1980. In 1981, she was made co-anchor on CBS's successful *Morning with Charles*

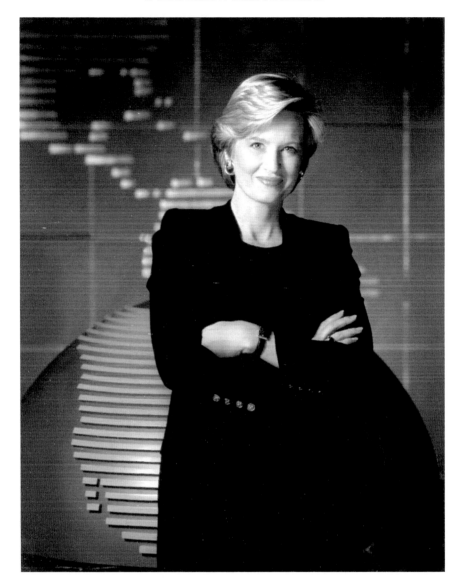

Diane Sawyer. *Courtesy of Special Collections & Archives, University of Kentucky.*

Kuralt and Diane Sawyer, after which, in August 1984, Sawyer became the first female reporter on *60 Minutes*.

In 1989, Sawyer moved from CBS to ABC to co-anchor *Prime Time Live* with Sam Donaldson. Since then, she has also hosted *Good Morning America* and *20/20* at ABC. Sawyer reported live from Ground Zero during the week of September 11, 2001. She also recently traveled to Afghanistan to reunite

with women she had interviewed in 1996 in her landmark series covering the plight of women under Taliban rule. Included in her long list of noteworthy interviews is George W. Bush's first national interview, an interview with Fidel Castro, Robert McNamara's public apology on Vietnam, Manuel Noriega's first interview from prison, Michael Jackson and his then first wife Lisa Marie Presley's only interview, Michael J. Fox's interview about the ravages he has experienced from Parkinson's disease and former first lady Nancy Reagan's discussions of President Reagan's struggles with Alzheimer's disease.

Sawyer has been married to director Mike Nichols since 1988; they have no children. At times, Diane Sawyer directs sharp questions toward those she is interviewing. She also has developed an affinity toward picking out interviewees who appear on a regular basis in the tabloids. Included, as a sampling, are interviews with Britney Spears, Marla Maples Trump and the Dixie Chicks. In the case of the Dixie Chicks, for instance, she repeatedly badgered the band for an apology after band member Natalie Maines, in reference to President George W. Bush, had proclaimed while onstage that her band was ashamed that the president of the United States was from Texas.

Sawyer has been showered with journalistic awards and recognitions for her work in the news. In 2001, she was named one of the most powerful women in America by *Ladies' Home Journal*, and in 2007 *Forbes Magazine* ranked her sixty-second on its list of the world's most powerful women. Sawyer and segment producer Robbie Gordon were named the 2004 George Polk Award winners for television, an annual award given by Long Island University to honor contributions to investigative reporting and journalistic integrity. A workaholic with getting the story and getting it right foremost in mind, Diane Sawyer has certainly come a long way since the days when she gave the weather reports on television station WLKY in Louisville, Kentucky.

George Clooney

1961–present

"Which Clooney is that, why it's George, of course."
George Clooney—Academy Award–winning movie star—from Augusta, Kentucky

George Clooney remains one of the most recognizable acting stars in the world. Recently deemed the world's "most eligible bachelor" by a popular print magazine, Clooney is known for his patented good looks as well as a "devil may care" approach to life. In many ways, Clooney is an enigma. When acting or directing, he is a consummate professional, and when speaking out on social and political issues he is passionate about his positions. Yet, off camera, while cavorting with his buddies, he is carefree and always up to or up for a good practical joke.

George is the son of television personality and newspaper columnist Nick Clooney and the nephew of deceased singer/actress Rosemary Clooney. George grew up in the tiny river community of Augusta, Kentucky, where he was a basketball and baseball star. After graduating high school in 1979, he had an unsuccessful tryout in baseball with the Cincinnati Reds and later enrolled to study acting and directing at nearby Northern Kentucky University. Much of George's time on campus was spent frolicking with other students. When he did attend classes, he could be a good student, but he never seemed to take his college experience too seriously.

A turning point in George's life occurred in spring 1981, when his cousins, Miguel and Rafi Ferrer (his Aunt Rosemary's sons), and their father, José Ferrer, were in Lexington, Kentucky, to film a movie. George was invited onto the set, loved what he saw and decided to become an actor. To get the money to take off to the land of movie making, George cut tobacco in the hot August sun, sold lemonade at the county fair and drew caricatures of local people.

In the fall of 1981, George left home to go to California to pursue his acting dreams. It took him two years to work through the acting "cattle calls"

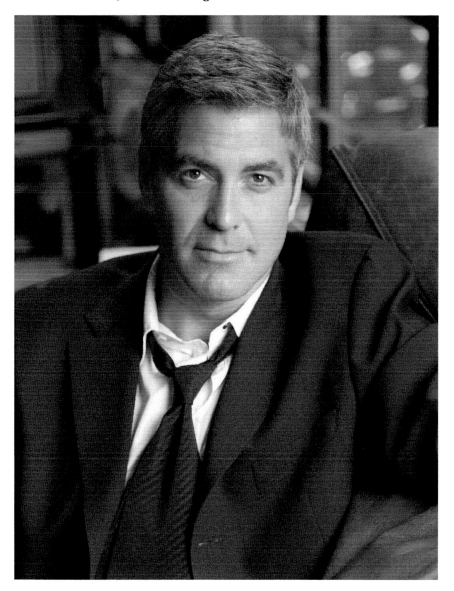

George Clooney. *Photo by Sam Jones.*

and occasional bit parts to become comfortable with his new life. Some small television roles led to several unsuccessful television pilots before, in the mid-1980s, he landed a role on *ER*, the breakthrough he needed. Clooney's role as Dr. Doug Ross, the handsome children's medical specialist, transformed George Clooney into a household name.

Clooney next turned to movies. His first major film role was in *From Dusk to Dawn* in 1996, and in 1997 he was reportedly paid $15 million to play the role of Bruce Wayne (Batman) in *Batman and Robin*. Besides retaining his good looks as he ages, Clooney has also proven to be a talented actor, one able to play an amazing variety of roles. He has shown considerable talent as a writer/director as well. He was actor, director and writer in the critically acclaimed movie *Good Night, and Good Luck* (2005), a tribute to famed journalist Edward R. Morrow, shot in black and white for contrasts and effect. Clooney's earlier roles in 2000 as the ill-fated intrepid sea captain in *The Perfect Storm*, and as a wisecracking escaped prisoner in *O Brother, Where Art Thou?* helped set the stage for Clooney's receiving an Academy Award in 2005 as best supporting actor in *Syriana* and being nominated as best director/writer in *Good Night, and Good Luck* that year. This was the first time anyone had been nominated by the academy for two different movies in two different categories.

Despite his many successes, George remains George. He owns a villa in Italy, and when he is there, he will regularly carry out the trash for the elderly neighbor lady next door. He also is a regular unannounced visitor to his hometown in Kentucky, where he can be seen strolling the town's streets, while the locals go about their business paying little or no attention to his presence. George and the locals, it seems, like it that way. When one local was asked by a Hollywood reporter what everyone thought about all of this, he responded, "Oh, it's just George, we're kind of used to him by now."

About the Author

James C. Claypool, professor emeritus of history at Northern Kentucky University, holds a PhD in European history from the University of Kentucky. He taught history in Kentucky for thirty-six years, first at Murray State University (1966–70) and then at Northern Kentucky University (1970–2002), where he was both its first employee and a dean. A well-known public speaker in Kentucky, he has been a featured speaker with the Kentucky Humanities Council for fifteen years. He is a nationally recognized authority on thoroughbred racing, especially the Kentucky Derby, and on Kentucky music and is published in both fields. He worked as the Smithsonian's Kentucky Derby expert in 1995 and in 2008 as the state coordinator in Kentucky of the Smithsonian's traveling exhibit on the roots of American music. Television and radio programs he has hosted and produced have won a number of regional awards. He has helped edit, coauthored or authored six books and one encyclopedia as well as published articles and encyclopedia entries on art, culture, politics and military history. He and his wife Sharon reside in Park Hills, Kentucky.

Visit us at
www.historypress.net

· ·

This title is also available as an e-book